Museums Matter

THE RICE UNIVERSITY CAMPBELL LECTURES

Other Books in the Series

The Writer as Migrant (2008)
by Ha Jin

Thousands of Broadways (2009)
by Robert Pinsky

Shakespeare's Freedom (2010)
by Stephen Greenblatt

Museums Matter

In Praise of the Encyclopedic Museum

JAMES CUNO

THE UNIVERSITY OF CHICAGO PRESS
Chicago & London

The University of Chicago Press, Chicago 60637
The University of Chicago Press, Ltd., London
© 2011 by The University of Chicago
All rights reserved. Published 2011.
Paperback edition 2013
Printed in the United States of America

22 21 20 19 4 5 6

ISBN-13: 978-0-226-12677-7 (cloth)
ISBN-13: 978-0-226-10091-3 (paperback)
ISBN-13: 978-0-226-06851-0 (e-book)
DOI: 10.7208/chicago/9780226068510.001.0001

Library of Congress Cataloging-in-Publication Data

Cuno, James B.
 Museums matter : in praise of the encylopedic museum / James
Cuno.
 p. cm.
 Includes bibliographical references and index.
 ISBN-13: 978-0-226-12677-7 (cloth : alk paper)
 ISBN-10: 0-226-12677-3 (cloth : alk. paper)
 1. Museums—Philosophy. I. Title.
 AM7.C87 2011
 069.01—dc23
 2011023608

for Gus

CONTENTS

List of Illustrations ix
Acknowledgments xi

INTRODUCTION 1

ONE The Enlightenment Museum 11

TWO The Discursive Museum 33

THREE The Cosmopolitan Museum 57

FOUR The Imperial Museum 89

EPILOGUE 115

Notes 123
Index 141

ILLUSTRATIONS

COLOR PLATES

Plates follow page 84.

1. Anon., ewer (ca. 1610)
2. Anon., talismanic textile (late nineteenth century)
3. Anon., *Thangka with Bhaishajyaguru* (thirteenth/fourteenth century)
4. Brice Marden, *Cold Mountain 2* (1989–1991)

FIGURES

1. Anon., dish (early fourteenth century) 48
2. Anon., vase (1700–1750) 49
3. Antonio Canova, *Head of Medusa* (ca. 1801) 60
4. Fang Gabon, reliquary head (mid-nineteenth century) 61
5. Edo, *Plaque of a War Chief* (sixteenth/seventeenth century) 64
6. John Singer Sargent, *The Fountain, Villa Torlonia, Frascati, Italy* (1907) 67
7. Anon., *Bodhisattva* (second/third century) 69
8. Brice Marden, *Zen Studies*, plate 1 (1990) 70
9. Brice Marden, *Zen Studies*, plate 3 (1990) 71
10. Brice Marden, *Cold Mountain 1 (Path)* (1988–1989) 72

ACKNOWLEDGMENTS

This book began as the 2009 Campbell Lectures, delivered at Rice University. The Campbell Lectures Series in Literary Studies was created and endowed by the late T. C. Campbell, Rice University Class of 1934. I am grateful to Gary Wihl, then dean of humanities at Rice University (now dean of arts and sciences at Washington University) for extending the invitation to deliver the lectures. I am equally grateful to Professor Allen Matusow, interim dean of humanities, and to Sarah Campbell and her family for their generous hospitality. The opportunity to present my scattered thoughts to a challenging audience of students and faculty over three successive days was an ideal way to have begun this book.

Between then and the book's completion, I spoke at Yale University, Duke University, and George Washington University, the University of Pennsylvania's Museum of Archaeology and Anthropology, the University of Chicago's Oriental Institute, City University of New York's Humanities Center, the University of Rochester's Memorial Art Gallery, and New York University's Humanities Center, Institute of Fine Arts, and La Pietra Policy Dialogues in Florence. I thank them for their kind invitations to speak. I am deeply in-

debted to the many students and faculty members at those insti-
tutions for their thoughtful questions, observations, and rebuttals.

This book is basically structured as the lectures were delivered,
although tightened and expanded here and there. I broke out the
introduction from the first lecture and added a fourth chapter,
which had its roots in the third lecture. I also added a brief epilogue.
After writing this book, I left the Art Institute to assume the posi-
tion of president and CEO of the J. Paul Getty Trust, which through
its exhibitions and research, conservation, and grant-making pro-
grams has global reach and addresses many of the same issues as
I am exploring here. Because I wrote this book as a director of an
encyclopedic museum, I have retained that voice throughout.

I am grateful to Alan Thomas, editorial director of humanities
and social sciences at the University of Chicago Press, for his keen
observations and interest in this project. Our lunches together,
talking about ideas and books, were stimulating and sustaining. I
am also grateful to Joel Score for his sharp editorial pen.

I should say something about books and authors. The greatest
pleasure of giving lectures, in addition to receiving helpful criti-
cism, is the enjoyment one gets from reading while preparing
them. I am aware that this book reads like an extended dialogue
with the authors of the books and articles I have been reading over
the past few years. I have had the good fortune coming to know
some of them, in various ways—Kwame Anthony Appiah, Homi
Bhabha, Dipesh Chakrabarty, William Dalrymple, Wendy Doniger,
Finbarr Barry Flood, Amartya Sen, and Kavita Singh—and their ex-
amples have been inspiring.

I leave my greatest gratitude for my family, who for years, on this
project and others, has put up with my writing on weekends and
over holidays with all the messiness that goes with it. Sarah, Claire,
and Kate are infinitely patient, good humored, and loving, and this
book is very much theirs too.

Museums Matter

It is 4:30 on a Thursday afternoon. From my office, I can see dozens of people standing in line waiting to enter the museum. We are open and have been for six hours already. The waiting people could enter now; others do. But every Thursday at five o'oclock we suspend our admission price and allow people in for free. And so they wait. In thirty minutes and over the course of the next three hours, the people outside my window will be joined by thousands of others, people of all ages and interests, from a broad range of ethnic, religious, social, and economic backgrounds, some experienced in museum going, others with little or no preparation, all of them coming to look at works of art.

In the coming year, close to two million people will come to the Art Institute of Chicago. I find this astonishing. Life is hard and people are busy. Those coming to the museum this evening are likely to have worked all day, fed their families, and traveled downtown by train, subway, bus, or automobile. Likely they're tired, and yet they have come to the museum. And they have done so when there are many other, equally free cultural activities nearby: across

the street in Millennium Park, with its interactive art installations and free concert pavilion, or farther on in Butler Field, with its weekly outdoor film screenings and frequent music festivals, or all around us in Grant Park, with its acres of open space for walking, riding bikes, playing games, or having picnics. What makes these people come to the museum now? Or on the weekend, when we charge admission but competing options remain free? This week, and every week, some forty thousand people will forgo other opportunities and responsibilities to come to the museum. Why?

We say we know: out of curiosity; for education, inspiration, entertainment, distraction, comfort, safety, a sense of community; to see beautiful things, new and different things; to have their view of the world enlarged, feel a part of something important—the long and richly textured history of human existence.

And what do we offer them in return? Our collections, often displayed with helpful and informative labels and accompanied by audio guides or gallery docents who will tell them something about the artists who made the works on view, the era in which they were made, their subjects, their importance in the history of art, and, not to be overlooked, their authenticity. Special exhibitions that focus on the work of a particular artist, artistic period, subject matter, or regional culture, that bring together works of art from disparate collections that can't otherwise be seen in just this way. Sometimes lectures, concerts, films, literary events, or educational workshops designed to enrich the experience of our collections. Always works of art.

Over the past twenty-five years, art museums have become surprisingly popular. According to the *Art Newspaper*, the thirty most popular exhibitions of 2009 attracted 12,361,882 people, while the Association of [North American] Art Museum Directors reported a total 2009 attendance of just over forty-two million at its top one hundred museums.[1] Museums have also become the subject of considerable academic scrutiny and criticism. These critiques have rarely been subtle. A pair of influential scholars wrote that "the museum is the site of a symbolic transaction between the visitor and the state. In exchange for the state's spiritual wealth, the indi-

vidual intensifies his attachment to the state."[2] Another argued, *à la* Foucault, that museums have replaced prisons as instruments of state power: "Rather than embodying an alien and coercive principle of power which aimed to cow the people into submission, the museum—addressing the people as a public, as citizens—aimed to inveigle the general populace into complicity with power by placing them on this side of a power which it represented to it as its own."[3]

I will consider the work of these and other museum critics later. It is enough here to point out the directness of their claims that museums have the power and authority to control their visitors and that they do so in the service of the state and a Western-centric view of the world. In their view, all of the people lining up outside my window waiting to enter the Art Institute—and all of the hundreds of thousands, indeed millions of others who will come to the museum this year—are participants in a ritualistic experience controlled by us. They will enter the Art Institute, visit our galleries, view our works of art, be subject to the hegemonic control of our city's political and financial elite, and have their commitment to the state intensified into the bargain.

Such criticism is fantasy. And we could dismiss it out of hand were it not so influential in the increasingly popular academic disciplines of cultural and museum studies.[4]

In the following pages, I will argue that the encyclopedic museum is precisely *not* an instrument of the state but is instead an argument against an essentialized, state-derived cultural identity in favor of a cosmopolitan one, one that acknowledges and demonstrates the truth of culture: that it has never known political boundaries but has always been dynamic and hybrid, formed through contact and exchange with diverse peoples. The encyclopedic museum respects the individual agency of the visitor, allowing her to follow her own interests and be surprised, challenged, and inspired by what catches her eye and compels her to wonder about a particular work of art—why it looks the way it does, how it might have been made, by whom and where, and what purpose and meaning it may have had for the first people who saw it and all who

subsequently came into contact with it before and after it entered the museum's collection.

: : :

The Art Institute was founded as an encyclopedic art museum. Within twenty years of its incorporation, in 1879, its collections included examples of ancient Greek, Etruscan, Egyptian, and Roman art, as well as Japanese ivory sculptures, Asian and Indian woven fabrics, Chinese bronzes, Syrian glass, Native American baskets, and European and American paintings and sculpture. A few years later we added African art and art from the Islamic lands.

The ambition to build such an encyclopedic collection was in part a response to Chicago's rapid economic development and population growth, which in turn was driven by extensive immigration. Barely more than two decades after incorporation, in 1837, with a population of just four thousand, Chicago boasted a canal and railroad system that linked the Great Lakes with the vast interior of the country, making it by 1854 the greatest primary grain port in the world. Over the course of the next seventy years it would serve as the hub of the nation's transcontinental trade and its most dynamic manufacturing center, the home of reaper works, steelworks for the railways, and vast furniture production, not to mention meatpacking, brewing, printing, and publishing. By the turn of the century, Chicago was the fastest growing city in the country, its population doubling from a little more than half a million in 1880 to a million in 1890, and again to over two million in 1910. By then, Chicago's population was exceeded in the United States and Europe by only New York, London, Paris, and Berlin.[5]

The allure of plentiful employment attracted a diverse population, first from Ireland, Britain, and Northern Europe, especially Germany, and then great numbers of Poles, Czechs, Serbs, Croats, Greeks, and Chinese. In 1860 Chicago's population was half foreign born; by 1890 it was 79 percent foreign born. The young city was ill-equipped to handle such a rapidly expanding and diverse population. Its urban and social infrastructure was insufficient. Housing

was a jumbled mess, with minimal public health accommodations. Great swaths of slum blocks had no sewer connections. There were no public playgrounds or bathhouses, no branch libraries, and limited access to public education. Workers of all ages were poorly paid and overworked. And in 1886, as strikes broke out all across the city, anarchists organized a rally at which a bomb was thrown, dozens of people were killed, and hundreds were arrested.

Chicago was struggling to adapt to new circumstances: a rapidly growing and changing population speaking different languages, practicing different customs, often living in segregated neighborhoods under compromised conditions. How to forge a common, civic identity out of this polyglot, multiethnic population of diverse religious practices living and working in such mixed and harsh conditions?

One way was to build cultural institutions open to all. In 1906 the architect Daniel H. Burnham was commissioned by the city's Merchant's Club (which later merged with the Commercial Club of Chicago) to devise a master plan for the city. As published in 1909, the Plan for Chicago proposed bold urban improvements, including a system of public parks throughout the city and along its many miles of lakefront. In the downtown park, in what the Plan calls the "Heart of Chicago," Burnham envisioned a campus of public learning that would include an art museum (the Art Institute), a museum of natural history (the Field Museum), and a great public library. These would be gathered together in the historic core of the city—on axis with a monumental civic center and within reach of a bustling commercial area and multiple public gathering spaces— examples of all the world's artistic, literary, and scientific achievements. As Burnham envisioned it, these public institutions would ennoble Chicago and her citizens and would contribute to the city's "spirit of civic unity."[6]

Together these institutions—now including the Chicago Symphony Orchestra, which moved into Symphony Hall, across the street from the Art Institute, in 1904, and the Shedd Aquarium and Adler Planetarium, which opened near the Field Museum in 1929 and 1930, respectively—collect and present examples of the

world's many cultures and introduce their visitors to the fecundity of the natural world and the vastness of the universe. And they do this for an increasingly diverse population. As of the 2000 census, 42 percent of Chicago's residents were of European descent and 37 percent of African descent. Hispanics comprised both the largest percentage of foreign-born residents (56 percent) and the fastest growing part of the city's population (up 38 percent over 1990). Chicago has the fifth largest foreign-born population in the nation, the second largest Mexican population (after Los Angeles), the second largest Puerto Rican population in the continental United States (after New York), the third largest South Asian population (after New York and San Francisco), and the third largest Greek population of any city in the world. Increasingly West Africans are moving to Chicago, especially Nigerians and Ghanaians; so too are Romanians, Assyrians, Ethiopians, and Somalis. Some 22 percent of Chicago's population still is foreign born (twice the national average). More than twenty-six ethnic groups are represented by at least twenty-five thousand residents each. And more than forty languages are spoken by at least a thousand people each.[7]

A common civic identity cannot be fixed. New waves of immigrants arrive. People of different ethnicities intermingle and marry. Economic circumstances shift and shift again, differently. One generation's housing solutions give way to new and different ones. Educational opportunities change and become more complex. Cultural identities are always contingent, negotiated and renegotiated; that we acknowledge. But at the Art Institute we remain committed to the idea that by presenting, without prejudice, works of art from the world's many cultures, we introduce our visitors not only to cultures distant from them in time and space but increasingly to the historic cultures of their Chicago neighbors. And in so doing, there is the possibility that they will come to experience a sense of community, of belonging, of joining their distinct claim on a historical identity with a new condition as a citizen of Chicago.

This I hold to be the promise of encyclopedic museums: that as liberal, cosmopolitan institutions, they encourage identification with others in the world, a shared sense of being human, of having

in every meaningful way a common history, with a common future not only *at stake* but increasingly, in an age of resurgent nationalism and sectarian violence, *at risk*.

In the chapters that follow, I will explore this promise, from its foundation in the British Museum as an Enlightenment institution to its current form in the postcolonial era. I will argue that Enlightenment principles still apply to the work of encyclopedic museums today: to gather, classify, catalog, and present facts about the world (in our case, works of art); to scrutinize unverified truths and oppose prejudice and superstition; to maintain belief in individual agency; to hold that all the arts and sciences are connected; and to be confident in the promise of rigorous, intellectual inquiry to lead to truths about the world for the benefit of human progress. I will argue against contemporary dismissals of Enlightenment thought and institutions as colonial enterprises, made possible by—and tending to reinforce—European (now "Western") dominance of the world. For, if nothing else, the Enlightenment taught us to examine all thoughts and evidence and hold none to be irrefutably true, not even Enlightenment principles themselves. As Kant concluded, "Our age is the age of criticism, to which everything must be subjected."[8]

I will also argue against the prevailing academic critique of museums as instruments of the state and forces for the propagation of the hegemony of the financial and political elite. Museums are public institutions open to all. We invite our visitors in and let them wander as they wish. They make their own way through our collections, drawn to individual works of art that attract their attention. They, our visitors, and not the museum, are the authors of their experiences with our collections. And while we are right to characterize their experiences as *narratives*, they do not constitute *metanarratives*, or comprehensive explanations of historical experience or knowledge. The sheer, stubborn matter-of-factness of works of art resists such narrative inflation.

I will suggest that one's experience of encyclopedic museums is akin to travel, travel literature, and translation. In this, I am indebted to Roxanne Euben's observation about early accounts of

Islamic travelers: "Texts that themselves reflect and enact such dislocation and, in particular, those that bring alive for a reader the experiences, press of events, fear, wonder, and sense of loss, at work in the jagged mediation between the familiar and unfamiliar can serve as an invaluable resource for those who do not or cannot travel, in part by enabling the imagination of and reflection on modes of life other than their own."[9] In chapter 3 I propose that the relocation of "foreign" works of art to new places and contexts is a positive development, drawing also on Edith Grossman's insight that "translation always helps us to know, to see from a different angle, to attribute new value to what once may have been unfamiliar. As nations and as individuals, we have a critical need for that kind of understanding and insight. The alternative is unthinkable."[10] I cite these authors by way of arguing that encyclopedic museums proffer the best chance for considering the relations between cultural artifacts, and thus hold promise as a means of complicating simplistic notions of cultural essentialism. In this my argument is enriched by the recent debate over cosmopolitanism—whether it is a faceless abstraction, an urgent alternative to nationalist fundamentalism, or a notion tragically compromised by the legacy of colonialism and the economic inequities of globalization.

Finally, in chapter 4, I reflect on the thesis of this book—that encyclopedic museums are cosmopolitan institutions dedicated to the proposition that, by gathering and presenting representative examples of the world's diverse artistic cultures "under one roof," work to dissipate ignorance and superstition about the world and promote tolerance of difference itself—in the context of postcolonial thought and the criticism that encyclopedic museums are really imperial institutions, built by and for rich and powerful first world nations at the expense of weaker, less developed nations, many of them former colonies. In this, I draw on the example of the contemporary literatary critic and scholar Edward Said, who wrote that the purpose of his discipline, comparative literature, which itself originated in the period of high European imperialism and is inevitably linked to it, "is to move beyond insularity and provincialism and to see cultures and literatures together, contra-

puntally." "There is," he observes, "an already considerable invest-
ment in precisely this kind of antidote to reductive nationalism and
uncritical dogma: after all, the constitution and early aims of com-
parative literature were to get a perspective beyond one's own na-
tion, to see some sort of whole instead of the defensive little patch
offered by one's own culture, literature, and history."[11] And in the
epilogue I reflect on the colonial enterprise in India and its effect
on art museums there, and the problematic absence in India of sig-
nificant encyclopedic museums.

In these arguments I mean to answer, in part, the question I
posed at the beginning of this book: Why do people come to mu-
seums like the Art Institute of Chicago in such great numbers? It
is, I hold, because they hunger to have their world enlarged, their
life enriched by the experience of new and strange, wonderful
things, and sense made of the differences they confront in the poly-
glot, multiethnic world in which they live, not just as a condition of
modern life in our globalized world but as a condition of life lived
throughout history, since people first traveled beyond their vil-
lages and came into contact and forged relations with people and
cultures unfamiliar to them. This is the promise of encyclopedic
museums and the reason we must not only ensure their survival
but encourage their propagation where they do not yet exist. This
is why *museums matter*.

The Enlightenment Museum

A comprehensive critique of what exists
marks the entrance to rationalist modernity.

ZEEV STERNHELL[1]

The encyclopedic museum is a modern institution, born of the in-
tellectual ferment of early modern Europe. Its founders were fig-
ures of the Enlightenment, confident in the promise of reasoned
inquiry and deeply skeptical of received and unverifiable truths.
The histories of the earliest such museums vary. The Louvre (1793)
was a former royal collection, nationalized in revolution and en-
hanced through political conquest, economic influence, colonial
occupation, and scientific expedition. The Hermitage (1852) was for
more than fifty years an imperial museum, then a state museum
through revolution and confiscation, whose collections grew much
like those of the Louvre. The original Berlin museums were not one
museum, but many, one museum next to the other on the Museum
Island in the center of the city, each established by the state with
the patronage first of the monarch, then the emperor, and each spe-
cializing in a different geographical region, world culture, or his-
torical period (the first, the Altes Museum, opened in 1830, and the
last, the Pergamon Museum, a century later).[2]

 The British Museum was established by an act of Parliament on
June 7, 1753. It comprised collections not of royal or imperial foun-

dation but assembled by individuals, chief among them the London physician Sir Hans Sloane. [3] Over the course of his long professional life, during which he succeeded Isaac Newton as president of the Royal Society, Sloane built a collection of specimens of all kinds and dedicated his later years to cataloging them; of the forty-six catalogs he either wrote or had produced, thirty-one survive. His was an internationally famous collection, visited by the Swedish botanist Carolus Linnaeus in 1736, the year after the latter published his influential *Systema Naturae*. Twelve years later, Linnaeus's assistant Per Kalm left a detailed inventory of Sloane's collection: "a polished agate which displayed in a most naturalistic manner an eclipse of the sun," "a device made of elephant bone with which the women of the East Indies scratch their backs," "the shoes of a grown up Chinese woman which were no bigger than those of a child of 2 or 3 years in Sweden," "the saw of a sawfish," "the headdress of a West Indian King made out of red feathers," "the stuffed skin of a rattlesnake," 336 volumes of dried and bound plants in royal folio, with as many plants mounted on each page as there was room for, "5300 volumes of manuscripts on medicine and natural history, bound in fine bindings," "the skeleton of an armadillo," "a porcupine from Hudson Bay," "an Egyptian mummy," "a striped donkey from the Cape of Good Hope," "West Indian boats made of bark," "all sorts of Roman and other antiquities," in an outbuilding, "the head of a whale;" and much, much more. [4]

On his death in 1753, Sloane's will directed his trustees to offer the collection to the nation to be made available to "all persons desirous of seeing and viewing the same, under such statutes, directions, rules, and orders, as shall be made, from time to time, by the said trustees . . . that the same may be rendered as useful as possible, as well towards satisfying the desire of the curious, as for the improvement, knowledge and information of all persons." On June 7, King George II gave his assent to the British Museum Act, accepting Sloane's collection and establishing the British Museum. The terms of Sloane's will as adopted in the Museum Act were simple: the "Museum or Collection may be preserved and maintained, not only for the Inspection and Entertainment of the learned and

the curious, but for the general Use and Benefit of the Public"; it "shall remain and be preserved therein for public Use to all Posterity"; and the "Repository shall be vested in the said Trustees by this Act appointed, and their Successors for ever, upon this Trust nevertheless, that a free Access to the said general Repository, and to the Collections therein contained, shall be given to all studious and curious persons." The museum's guiding principle, consistent with Sloane's own belief, was that "all Arts and Sciences have a Connexion with each other, and Discoveries in Natural Philosophy and other Branches of speculative Knowledge, for the Advancement and Improvement whereof said Museum or Collection was intended, do and may in many instances give Help and success to the most useful Experiments and Inventions."[5]

Two things are important about the founding of the British Museum. First, while Sloane preferred that his collection reside in London, he had instructed his trustees to offer it in turn to the royal academies of science in St. Petersburg, Paris, Berlin, and Madrid if George II did not accept the terms for its public presentation: that it be kept together for study and be free and open to all "studious and curious persons." And second, although it was a national museum—it belonged to the nation, not the king (Parliament borrowed the concept of a trust from civil law and appointed trustees to administer the collections)—it was not a *nationalist* museum. It did not present a national narrative extolling the glory of Britain or of Britishness. The Louvre, by contrast, was established explicitly for just such purposes. In a letter of October 1792, the French minister of the interior, Jean-Marie Roland, wrote to the painter Jacques-Louis David, to whom the founding of the museum had been entrusted: "This museum must demonstrate the nation's great riches. . . . France must extend its glory through the ages and to all peoples: the national museum will embrace knowledge in all its manifold beauty and will be the admiration of the universe. By embodying these grand ideas, worthy of a free people . . . [it] will be among the most powerful illustrations of the French Republic."[6]

The British Museum meant rather to tell a narrative about the world. From the beginning, its collections were representative of

the world's diverse cultures and natural phenomena, gathered, cataloged, and presented with encyclopedic ambition. (Its current director, Neil MacGregor, notes that one of the great surprises for many first-time visitors to the museum is how few *British* things are in its collection.)[7]

The museum's founding principles and the range and character of its collections were in keeping with the Enlightenment's trust in science and the systematic taxonomy of evidence and knowledge. Already a century earlier, Francis Bacon held that the only scientific method for understanding the world was to amass observations and theorize from the evidence thereby compiled. This was made all the more necessary as increased exploration and trade compounded evidence of the world's extraordinary diversity. If, for example, in 1600 there were around six thousand known plant species, by 1700 there were twice that number, and the same was true of artificial things.[8] Contact with the peoples of the Americas and Asia introduced Europeans to an astonishing range of things and competencies unknown to them. To give just one early example: in 1519 the conquistador Hernán Cortés received tribute gifts from the Aztec king Montecuhzoma II and sent them back to his patron, Charles V, in Madrid. When Albrecht Dürer saw some of these things on display in Brussels in 1520, he remarked, "All the days of my life I have seen nothing that rejoiced my heart so much as these things, for I saw amongst them wonderful works of art, and I marveled at the subtle *Ingenia* of men in foreign lands."[9] This would only be much more the case two and a quarter centuries later when the British Museum opened its doors to the public.

The collection on which those doors opened in Bloomsbury in 1759 was very different from that which we see in the museum today.[10] It comprised both natural and artificial things arranged in a "methodical manner": anatomical specimens, vertebrates and invertebrates, minerals and fossils, botanicals, coins and medals, antiquities—Egyptian objects separated from prehistoric European and British, Asian, and later medieval objects—ethnographic collections, prints and drawings, books and manuscripts. Natural history dominated the extent and presentation of the collections until

the receipt of William Hamilton's collection of Greek vases in 1772, when the balance began to shift toward antiquities and other artificial creations representative of both ancient and modern cultures from around the world. By 1807 a Department of Antiquities had been founded. In 1812 the Parthenon Marbles arrived. And in 1860, largely as a result of excavations in Assyria at the ruins of Nimrud during the 1840s and in Turkey at the remains of the Mausoleum of Halicarnassus during the 1850s, the Department of Antiquities was broken up into three parts: Greek and Roman Antiquities, Coins and Medals, and Oriental Antiquities. In 1880, due to both the burgeoning size of the collection and the development of greater specializations in the classification of knowledge, the natural history specimens, including the mineralogical, geological, and botanic collections, were moved to a new museum building in South Kensington. There they remained as part of the British Museum until a separate board of trustees was established for the Natural History Museum in 1963.

The breadth of the museum's collections was characteristic of the Enlightenment's view of the world and the means of making an account of it. To begin to know the world, one had to build an archive, as large as possible, of its many parts. Collecting things and describing and classifying them made it possible to propose relationships among them. Collecting more allowed one to test one's hypotheses. Eventually, through a rigorous scientific examination of the world—its natural, physical, and cultural characteristics— one could learn truths that could be applied to economic and human behavior for the benefit of humankind.

This same rigor applied to connoisseurship, or the consideration of artificial things as works of art. Enlightenment collectors were critical of their predecessors, whom they considered mere amassers of things that, once gathered, were arranged indiscriminately. Those who collected antiquities were criticized for their text-based approach—their analysis of antique remains by reference to ancient texts, as illustrations rather than as things of interest in themselves.[11] In 1719 the painter and collector Jonathan Richardson published his theories on connoisseurship in two Discourses—The

Connoisseur: An Essay on the Whole Art of Criticism and *An Argument on Behalf of the Science of a Connoisseur*. "To be a connoisseur," he wrote, "a man must be as free from all kinds of prejudice as possible; he must moreover have a clear and exact way of thinking and reasoning, he must know how to take in, and manage just ideas and, throughout, he must have not only a solid but unbiased judgment." Acknowledging his debt to Lockean empiricism, Richardson argued that connoisseurship required logical demonstration: "We must examine up to first principles, and go on step by step in all our Deductions, contenting ourselves with that degree of light we can thus strike out, without fancying and degree of assent is due to any proposition beyond what we can see evidence for. . . . If the nature of the thing admits no proof, we are to give no assent."[12] In 1735 Alexander Gottlieb Baumgarten coined the term *aesthetics* to designate "a science of how things are to be known by means of the senses," a definition he later refined to "the science of sensitive cognition."

It is important to recall—and befits the character of the British Museum's collections—that scientific inquiry was a central practice and model for most intellectual pursuits during the Enlightenment. Its ready application was such that, as a word, "science"—or rather "natural philosophy," the term most often used at the time— did not denote a separate field of intellectual endeavor but a way of knowing the world, a means of gathering evidence, classifying it, deducing verifiable truths from it, and then subjecting those truths to further skeptical inquiry. Science in this sense took place in a variety of overlapping fields of study, encouraged thinkers to cross disciplinary boundaries, and brought rigor to both the separate fields of inquiry and their points of intersection or overlap. As the British Museum Act put it, "All Arts and Sciences have a Connexion." Collecting things—artificial and natural—from all over the world and bringing them together under one roof for public presentation and careful, sustained study was intended to stimulate critical inquiry into that "connexion," which meant of course the propagation and testing of hypotheses and the pursuit of truths about the world.

This was also the ambition of encyclopedias and dictionaries like Ephraim Chambers's *Cyclopaedia, or an Universal Dictionary of Arts and Sciences*, published in 1728, Diderot's *Encyclopédie*, which began to appear in Paris in 1751, Samuel Johnson's *Dictionary of the English Language*, first published in 1755, and the *Encyclopaedia Britannica*, which first appeared in 1768.[13] These were designed to present in a condensed and systematic way all that was known about a language or the world and, importantly, to put this knowledge into the hands of curious individuals. This was a bold and, especially in France, a dangerous idea. Diderot's *Encyclopédie* not only provided information, it recorded knowledge according to Enlightenment philosophic principles and challenged the received authority of the church and state. As Robert Darnton described it, "The great ordering agent [of the *Encyclopédie*] was reason, which combined sense data, working with the sister faculties of memory and imagination. Thus everything man knew derived from the world around him and the operations of his own mind." The *Encyclopédie* was so threatening that in 1759 Pope Clement XII warned all Catholics who owned a copy to have it burned by a priest or face excommunication.[14]

There were reasons to be frightened of ideas getting into the minds of individuals, at least if you were an authority hoping to control their meaning. Access to ideas empowered individuals and fueled their agency as freethinkers. And in the thriving print culture of Enlightenment London, the population of freethinkers was threateningly large. Johnson's *Dictionary* was first printed in an edition of two thousand at a cost of four pounds, ten shillings; a second, more popular edition quickly followed in 165 weekly sections sold at sixpence each. The *Encyclopaedia Britannica* was also published in parts at sixpence each, and ten thousand copies of the third edition were sold between 1787 and 1797. Between 1660 and 1800 over three hundred thousand separate book and pamphlet titles were published in England, amounting to perhaps two hundred million copies in all. By 1712 London had a score of single-sheet newspapers, selling some twenty-five thousand copies a week. By 1800 provincial newspapers were selling over four hundred thousand copies each week, and more than 250 periodi-

cals had been launched. There were around a hundred book clubs in London, some with circulating libraries of substantial size (Bell's claimed to hold 150,000 volumes).[15]

At the same time coffeehouses proliferated—in 1739 some 551 in London alone—and there people gathered to discuss and debate the latest news. Ideas circulated and were debated; newspapers were read and handbills distributed. The Abbé Prévost called London's coffeehouses "the seats of English liberty."[16] And they were only part of a thriving public, intellectual culture in London, which also included reading societies, debating clubs, assembly rooms, galleries, and concert halls. It was a time, as John Brewer has written, when high culture as "a phenomenon shaped by circles of conversation and criticism formed by its creators, distributors and consumers" shifted from the court to the city and became a partner with commerce.[17] Coffeehouses were at once themselves commercial establishments and the site of commercial speculation, where deals were cut, partnerships formed, and professional activities discussed—indeed, the modern stock market originated at Jonathan's Coffee House in Exchange Alley. Booksellers met at the Chapter Coffee House in Paternoster Row, where in 1777 they commissioned Samuel Johnson's *Lives of the English Poets*. Artists from Hogarth to Roubiliac (whose sculpted bust of Sloane remains in the collection of the British Museum) met at Old Slaughter's Coffee House in St. Martin's Lane with the connoisseur Jonathan Richardson to discuss common concerns about the visual arts. Opera singers and dancing masters gathered at the Orange in the Haymarket. Books, prints, medals, and paintings were exhibited and sometimes sold, orations delivered, plays and operas performed. Coffeehouses were places of free expression, open to members of all social classes. As Brewer has described them, they "encouraged a polyphony of public conversations which challenged the voice of the crown" and "undermined the hierarchical values of monarchical absolutism."[18]

Above all, they were central to the development of the modern public sphere, and in eighteenth-century London, that sphere was set in the context of a dynamically changing city. In 1500 London's population had been only about 50,000, a third that of Paris and

Naples. By 1650 it was 400,000, and by 1700 it was 575,000, equal to that of Paris. One hundred years later it was 900,000. London had become the largest city in Europe, almost twice the size of Paris, exceeded in the world only by Edo (today Tokyo), Peking, and Constantinople. Its dominance was even more marked at home. By midcentury London was home to one in ten Englishmen, and over the course of the century it is estimated that one in six Britons spent at least part of their working life in the city. It was ten times larger than any other English city, the national seat of government, the principal residence of the court, an international port, and Europe's largest industrial city during an age of workshop industry. It had more doctors and lawyers than the rest of the country put together. Its banking and finance houses created large numbers of what we would call accounting and brokerage jobs. And of course its importance in world trade made it a center for traders, sailors, and goods carriers.

London was also the head of a growing political and financial empire. The volume of Britain's trade tripled in the eighteenth century, and by the 1770s it was fully international in scope, with 60 percent of exports accounted for by imperial markets in America, Africa, and Asia. The city's quays handled 80 percent of the country's imports, 69 percent of its exports, and 86 percent of its reexports. London became the model international entrepôt. Along with immigrants from Ireland and sailors and merchants back from the Americas and the East Indies, it had a larger black population than any city outside Africa (due in great part to Britain's leading role in the Atlantic slave trade). The introduction of such an extraordinary array of the world's goods and people considerably reshaped the city. This is where Sloane wished to establish what would become the British Museum: in the center of one of the world's largest and busiest cities, where people and things from all over the world lived and worked.

To be sure, Sloane and his peers enjoyed the benefits of class privilege and imperial bounty—just as they believed in the intrinsic superiority of European, even British, civilization—but Sloane was no less attached to his vision of a museum where all people, re-

gardless of social standing, could go to explore the fecundity of the world's natural history and the diversity of its cultures, from which much could be learned.[19]

Access to information on a scale unparalleled in history and promotion of scientific inquiry without regard to disciplinary boundaries resulted in a culture of what today we might call public intellectuals. The gentleman botanist and ethnographer, coffee shop orator, social club philosopher, newspaper journalist, periodical commentator, and independent man of letters all contributed to the exchange of ideas and the formulation of an intellectual program that challenged *a priori* truths and the authorities that propagated them. The philosopher David Hume, who served as secretary to the British embassy in Paris and then as an undersecretary of state in London, railed against such authorities, especially self-absorbed academics who "never consulted experience in any of their reasonings, or who never searched for that experience, where alone it is to be found, in common life and conversation." "The separation of the learned from the conversable world," he proclaimed, had been "the great defect of the last age," in which learning had "been as great a loser by being shut up in colleges and cells."[20] Enlightenment, it was held, ought to be available to everyone whose intelligence could be cultivated by access to clearly articulated and argued philosophical positions. Clear thinking, plain words, candor, and modesty were to be the intellectual's goals, setting reality above verbality and creating "a commonwealth of polite letters."[21]

This "commonwealth" was to be forged on the crucible of the public sphere, where ideas were proposed, debated, refuted, or rejected. Among those great ideas was the political philosophy of liberalism grounded in "its understanding of human nature, its respect for both individualism and equality, its discovery of the social, its passion for justice, its preference for experience over theory, its intellectual openness, its commitment to fairness."[22] At liberalism's core were the principles of freedom, equality, and rights, both individual and human, shared equally by all. As Kant wrote, "if all individuals are free, they must necessarily be equally so; for the freedom of all individuals is absolute and can only be universally and equally

restricted by law. . . . The idea of freedom entails the individual's autonomy, for it postulates the individual's power of exercising his will independently, uninhibited by improper constraint."[23] Enlightenment thinkers insisted on this: individuals have the right to, and by their agency can, reject constraints imposed by authorities over which they have no control or that are shaped by traditions over which they have no influence. Only constraints established by the people themselves through some form of consent or social contract were acceptable.

This was the basis of all human rights as stated in the American Declaration of Independence of 1776, where Thomas Jefferson wrote, "We hold these truths to be self-evident, that all men are created equal, that they are endowed by their Creator with certain unalienable Rights, that among these are Life, Liberty, and the pursuit of Happiness" and "That to secure these rights, Governments are instituted among Men, deriving their just powers, from the consent of the governed,—That whenever Form of Government becomes destructive of these ends, it is Right of the People to alter or to abolish it, and to institute new Government."[24] Such ideas were influential on French republicans, including the Marquis de Lafayette, who drafted the Declaration of the Rights of Man and Citizen, adopted by the French National Assemble in August 1789, which included the statements that "The purpose of all political association is the preservation of the natural and imprescriptible rights of man. These rights are liberty, property, security, and resistence to suppression" and " The principle of all sovereignty rests essentially in the nation. No body and no individual may exercise authority which does not emanate expressly from the nation [as constituted by its citizens]."[25] Such declarations rested on the belief that human rights were natural, and equally and universally shared. Of course, the hard truth was that this equality did not apply to everyone, not even to all men. But as aspirations, such declarations formed the foundation for broadening access to human rights.[26]

This was the context for the founding of the British Museum, the first true public encyclopedic museum: a cosmopolitan urban center with a diverse and rapidly expanding population and a dis-

putatious culture of debate and published argument, opposed to prejudice and superstition, suspicious of received truths and the specialization of knowledge, confident in the promise of science—the gathering, classifying, and cataloging of facts about the world—to yield truths that would contribute to human progress, and grounded in individual agency, voluntary association, and human rights. In every respect the encyclopedic museum—like the encyclopedia itself, dedicated to gathering as many specimens of nature and the world's cultures as possible, for the curious and scholarly alike—was an Enlightenment institution.

: : :

"What is Enlightenment?" The question was first posed in a footnote to an essay published in the *Berlinische Monatsschrift* in December 1783. Nine months later Immanuel Kant responded:

> *Enlightenment is man's emergence from his self-incurred immaturity. Immaturity* is the inability to use one's own understanding without the guidance of another. This immaturity is *self-incurred* if its cause is not lack of understanding, but lack of resolution and courage to use it without the guidance of another. The motto of enlightenment is therefore: *Sapere aude!* Have courage to use your *own* understanding![27]

For Kant, enlightenment was a process, an attitude or spirit of critique opposed to dogmas and formulas (the "ball and chain of permanent immaturity," he called them). All that was needed to achieve enlightenment was "freedom to make *public use* of one's reason in all matters":

> The *public* use of man's reason must always be free, and it alone can bring about enlightenment among men; the *private* use of reason may quite often be very narrowly restricted, however, without undue hindrance to the progress of enlightenment. But by the public use of one's own reason I mean that use which anyone may make of it *as a man of learning* addressing the entire *reading public*.[28]

Kant believed he was living in an age of enlightenment. It was a time of robust mediation of ideas through an evolving infrastructure of popular communication. In England a public postal service for private letters was officially established in 1660, and the Postal Bill of 1710 standardized postal rates throughout the British Empire. People could exchange ideas more easily than ever before. They could publish their ideas and opinions for others to read in the rapidly growing number of newspapers, gazettes, and magazines, especially magazines devoted to criticism, like the *Monthly Review*, which first appeared in 1749, and the *Critical Review*, six years later. And they had recourse to common repositories of facts and ideas: dictionaries and encyclopedias. The ambition was "access to all knowledge for all people," *public* not private knowledge. As two scholars have described it recently, "On this new platform, each individual came to be understood—and the result deployed—as working not only on its own terms but also as a part of a cumulative, collaborative, and ongoing enterprise"; "a commonwealth of learning," as the encyclopedist Ephraim Chambers put it.[29]

We are heirs to the Enlightenment, connected not by "faithfulness to doctrinal elements, but rather [by] the permanent reactivation of an attitude—that is, of a philosophical ethos that could be described as a permanent critique of our historical era."[30] For some thinkers, such a critique has led to the rejection of the Enlightenment's confidence in disinterested inquiry, universal principles, and verifiable truths. For Foucault, truth was the will to power within discourse: "What makes power hold good, what makes it accepted, is simply the fact that it doesn't only weigh on us as a force that says no, but that it traverses and produces things, it induces pleasure, forms knowledge, produces discourse."[31] For Derrida, there was no truth outside language, only the endless play of signifiers. And for Lyotard, sweeping theories about reality were metanarratives, master narratives reinforced by power structures—government, science, history, the university, the museum—stories told to legitimize various versions of the truth. For some postcolonial critics, scientific reasoning is seen as a legacy of colonial control. As Dipesh Chakrabarty puts it, "This strong split between emotion

and reason, I suggest, is part of the story of colonialism in India. Scientific rationalism, or the spirit of scientific inquiry, was introduced into colonial India from the very beginning as an antidote to (Indian) religion, particularly Hinduism, which was seen—by both missionaries and administrators, and in spite of the Orientalists—as a bundle of superstition and magic."[32] Faith in reason, which he calls "Enlightenment rationalism," is a failure that binds "the intellect of the colonial modern" to "a paradigm that sees science and religion as ultimately, and irrevocably, opposed to each other."

And yet one senses a revival of interest in the Enlightenment. Recent books range from general surveys to comparative studies of the Enlightenment in Scotland and Naples to specific investigations of its role in eighteenth-century European politics and the sciences, the Enlightenment from the perspective of women and the role of gender, the influence of geography on its development and formulation, the influence of Asian thought on Enlightenment Western thought, even postcolonial Enlightenment and the Enlightenment Qur'án. There is a recent four-volume *Encyclopedia of the Enlightenment* and "The Re:Enlightenment Project," a study premised on the idea that the "Enlightenment of the eighteenth century—the revolution in tools, methods, and institutions that recast inquiry and enterprise in the West—still shapes the ways in which knowledge is produced and disseminated today."[33]

I want to look at just two recent books in what I am calling a revival of interest in the Enlightenment and its principles: one a slim but compelling defense of the Enlightenment, and the other a sustained critique of the "Anti-Enlightenment" tradition.

: : :

The French philosopher Tzvetan Todorov's defense of the Enlightenment, published in 2006 (English translation, 2009), was written from the perspective of post-9/11 Europe and at a time of vigorous, even violent cultural contest within France.[34] (In October 2005 riots broke out in a poor Paris suburb, home to a large Muslim and North African population. Over the next two weeks, rioting spread to

other suburbs and to cities as distant as Marseilles and Dijon. This coincided with a loud, public controversy over the banning of Muslim head scarves in public schools. According to many, the rise of Islam in France was seen at the time as the greatest challenge to the country's proud secular tradition.)[35] Todorov turned to the Enlightenment to establish a moral base from which "to build our communal life" and "conduct ourselves as responsible human beings."

He begins by praising the Enlightenment's commitment to critique and its defense of an individual's inalienable right to freedom:

> What we need today is to re-establish the past heritage while subjecting it to a critical examination, lucidly assessing it in light of its wanted and unwanted consequences. In doing so, there is no risk that we will betray the Enlightenment. Just the opposite: it is through criticism that we remain faithful and put its teaching into practice.

> Belonging to the human race, to universal humanity, is more decisive than belonging to a specific society. The exercise of freedom was therefore contained by the principle of *universality*; and sacrality, which had broken free from dogmas and relics, finds embodiment in these newly recognized "rights of man."[36]

In both respects, Todorov's source is Kant. Like Kant, Todorov argues that all human beings have the inalienable right to be free, equal, and self-dependent. And if all individuals are free, they must necessarily be equally so. This value Kant and Todorov hold to be absolute: that the idea of freedom entails the individual's autonomy and postulates the individual's power of exercising his or her will independently, uninhibited by improper constraint.[37] It also compels her to work toward the establishment of a cosmopolitan society: for freedom to prevail among people within a state, their freedom must not be threatened by the action of other states.[38] Enlightenment opens up to the promise of cosmopolitanism because it respects difference in the world: "The Age of the Enlightenment was characterized by the discovery of the foreignness of others, whether they lived in an earlier time or somewhere else.

They were no longer seen as an embodiment of our ideal or as a distant forerunner of our current perfection, as had been the case at other times. But this recognition of the plurality of the human species is fertile only if it avoids radical relativism and does not prompt us to give up on our common humanity."[39]

There is a sense of urgency in Todorov's writing. We are living in an age where the alternatives of cultural relativism and essentialized differences enforced by military might promise only a downward spiral into a reductive nationalism that prevents us from getting a perspective beyond our own, local preoccupations. By contrast, "the lesson of the Enlightenment consists in saying that plurality can give rise to a new unity in at least three ways: it encourages tolerance through emulation; it develops and protects a critical spirit; and it facilitates self-detachment, which leads to a superior integration of the self and other."[40]

The second book, Zeev Sternhell's *The Anti-Enlightenment Tradition*, appeared in France in the same year as Todorov's and was published in an English translation in 2010. Sternhell writes from the perspective of a cosmopolitan Israeli political scientist widely regarded for his critical studies of fascism and controversial within Israel for his opposition to Jewish settlements on the West Bank (in 2008 he was the victim of a pipe bomb attack by a right-wing Israeli extremist). He takes as his starting point the coincidence that "while the eighteenth century is commonly perceived as the quintessential age of rationalist modernity, it was also the cradle of a second and strikingly different modernity": a revolt against not only the Franco-Kantian Enlightenment but also the British Enlightenment of Hume and Locke, and especially the latter's formulation of individualism and democracy. "It was precisely against this new vision of history, man, and society, against the new theories of knowledge, against the famous Kantian *sapere aude*, against the vision of the Enlightenment as a movement of emancipation of reason, of resistance to all forms of unjustified domination and against ideological dogmatism that all the variants of the Anti-Enlightenment revolted."[41]

Sternhell's chief early anti-Enlightenment figures are Giambat-

tista Vico, Johann Gottfried von Herder, and Edmund Burke. Vico argued against the ideas that we can take ourselves out of the state of nature by the power of reason alone and that civil society was the creation of free and equal individuals endowing themselves with social and political structures. Sternhell summarizes Vico's view thus: "The individual is caught from the time of his birth in a network of social relationships which he has not created and which vary from one period to another, from one place to another, [which] produced this other modernity based not on what unites men but on what divides them."[42] Herder's anti-Enlightenment revolt took the form of opposition to claims of universally valid principles. For Herder, the individual instance was more revealing and couldn't be subsumed under general laws. "The concept of the preeminence of history and culture, of the link with one's native soil, which with Herder took on a sense of almost physical attachment, gave rise to the affiliation of the *Kulturvolk* with the *Kulturstaat*. It was Herder's cultural nationalism that laid the foundations of political nationalism."[43] Herder's legacy, as Sternhell sees it, is that "cultural nationalism very soon gave birth to the idea of the national state and its counterpart, the supremacy of the state and the idea that democracy is the enemy of the people": "For the German philosopher took the historical corpus he found in his predecessors and turned it against them by creating an alternative that was antirationalist, Christian, antiuniversalist, anticosmopolitan, particularistic, and by that very fact nationalistic."[44] For Burke, finally, the nation is not a thing of mere physical locality but consists, in great measure, in the ancient order into which we are born: "Next to the love of parents for their children, the strongest instinct both national and moral which exists in man is the love of his country."[45]

Sternhell's complaint against these anti-Enlightenment figures (and their successors, from Hippolyte-Adolphe Taine to Isaiah Berlin), is their dismissal of the power of individual human agency through the exercise of free will and reason, and their glorification of the nation as having an objective existence and an organic nature. For them, the nation preexists the individual.

Giving priority to the nation not only diminished the place of

the individual—was in a very real way, *antidemocratic*—but privileged particularism with all of its violent consequences. In the final analysis, Sternhell asks, did Herder contribute to the unity of the human race or to it fragmentation? "To openness or to the idea of cultural self-sufficiency, to the particularism and specificity expressed in the cult of national geniuses and characteristics that ends by promoting perpetual conflict, or to the cosmopolitan ideal of Humanität?" Looking back over the long violent centuries that followed, Sternhell concludes, "the former." "Nationalism, in the sense it was given in the twentieth century, was not what Herder intended," he acknowledges, "and he could in no way foresee its ultimate developments, but these developments were nevertheless foreshadowed in his long campaign for the preservation of national, psychological, linguistic, cultural, and historical particularities."[46]

Sternhell concludes with a powerful summary critique of the legacy of the anti-Enlightenment:

> It was not "belief in a universal truth" that caused the massacres of the twentieth century; it was not a desire to break away from the existing order or the idea of the right to happiness that motivated them but, on the contrary, an eruption of irrationality, the destruction of the idea of the unity of human race and an absolute faith in the capacity of the political power to mold society. These were precisely the evils the Enlightenment fought against, and the Enlightenment, as Spengler and Sorel so rightly said, though in a spirit of disparagement, exists in every period. Progress may not be continuous, history may advance in zigzags, but that does not mean that humankind must trust to chance, submit to the regime of the hour, and accept social evils as if they were natural phenomena and not the result of an abdication of reason. To prevent the people of the twenty-first century from sinking into a new ice age of resignation, the Enlightenment vision of the individual as creative of his or her present and hence of his or her future is irreplaceable.[47]

Todorov's and Sternhell's books appeared in the same year. And although of divergent scholarly ambitions—Todorov's is pocket-size

and easily accessible, more a public manifesto than a book; Stern-hell's is a work of substantial scholarship, an argument within his professional discipline, albeit with wider application—they come to the same conclusion: we still have much to learn from the Enlightenment. The exercise of reason, opposition to dogma, respect for individual freedom as an inalienable human right, and regard for the cosmopolitan ideal of *Humanität*—these are values as relevant today as ever. We live in a world of resurgent nationalism and sectarian violence propagating ideologies of inevitable civilizational conflict. If the Enlightenment was in part a response to the bloody wars of religion, factionalism, public violence against the British king, and the Glorious Revolution that marked the years 1649–1688, the wars and terrible violence of our recent past and present time compel us to recommit ourselves to the principles of enlightenment.

As Todorov says at the conclusion of his book:

> We are all children of the Enlightenment, even when we attack it; at the same time, the ills fought by the spirit of the Enlightenment turned out to more resistant than eighteenth-century theorists thought. They have even grown more numerous. The traditional adversaries of the Enlightenment—obscurantism, arbitrary authority and fanaticism—are like the heads of the Hydra that keep growing back as they are cut. . . . There is reason to fear that these attacks will never cease. It is therefore all the more necessary to keep the spirit of the Enlightenment alive. . . . This would be the vocation of our species: to pick up the task of enlightenment with each new day, knowing that it is interminable.[48]

: : :

I will pick up the thread of this argument in chapter 3. I want now to return to the matter of the encyclopedic museum.

Encyclopedic museums build—have always built—their collections to be representative of the world's artistic legacy and to provide sufficiently robust data groups from which to deduce truths. They explore these data as physical things: how they were made,

how their physical properties have changed over time, who made them and how one knows that, who's owned them and seen them and how one knows that. Then they consider how they work, how their parts come together to mean something, what they were used for, and how their use shaped their reception and gave them public meaning. And they document all of this and publish it for public consumption and scholarly critique. This is the promise of encyclopedic museums, and has been ever since the British Museum was founded in 1753.

As Sloane's will had it, the first encyclopedic museum's collection was to be made publicly accessible to all learned and curious persons for the advancement and improvement of speculative knowledge. Such knowledge cannot be determined beforehand. It derives from acquisition, investigation, experimentation, and reexamination. And it is public knowledge, made public to amateurs and specialists alike, without preconditions or preference.

Encyclopedic museums hold to the principle of universal access to knowledge. And they presume that knowledge will change. Different people will ask different questions of the objects in their collections. Sloane preferred that his collection remain in London, but he would have allowed it to go to any other metropolitan city with a serious commitment to scientific inquiry. He gave his collection "more to a purpose than to a place."[49] But he wanted that place to have a mix of peoples—peoples who, like the artifacts in his collection, represented the world. And London had such variety, more than any other city in the world at the time.

Sloane could not have imagined the extraordinary diversity of London today, nor that of many other European or North American cities. But he wouldn't be surprised to find encyclopedic museums in all such cities, for difference breeds curiosity about difference. If encyclopedic museums hold the promise I believe they do—that from curiosity come tolerance and understanding—we should encourage their creation everywhere. Without such institutions, one risks a hardening of views about one's own, particular culture as being pure, essential, and organic, something into which one is born, something one cannot change or rise above through the

exercise of free will and reason. The collective, political risk of not having encyclopedic museums everywhere possible—in Shanghai, Lagos, Cairo, Delhi, and all other major metropolises—is that culture becomes fixed *national* culture, with all the dangers entailed by the fragmentation of humanity that Sternhell describes.

TWO

The Discursive Museum

> When we concentrate on a material object, whatever its situation, the very act of attention may lead to our involuntarily sinking into the history of that object.

VLADIMIR NABOKOV[1]

Shortly after the British Museum opened in Montagu House in 1759, its head of Natural and Artificial Productions, James Empson, who previously had been Sir Hans Sloane's curator, remarked on the installation of what was now a public collection: "How much soever a private Person may be at Liberty arbitrarily to dispose & place his Curiosities; we are sensible, that the British Museum, being a public Institution subject to the Visits of the Judicious & Intelligent, as well as Curious, Notice will be taken, whether or no the Collection has been arranged in a methodical Manner."[2] In other words, for the sake of the public, for which the collection was held in trust, the museum felt obliged to present its objects and things in a systematic way. It wasn't enough simply to display them; the display had to accord with a reasonable system of classification.

But even that wasn't enough, because some things were more important and more alluring than others. "In disposing of each Subdivision," Empson continued, "to take particular Care, that those Matters may be brought nearest the Sight, as are most pleasing to the Eye and of most Consideration; placing the Rest, in Proportion as they are less so, higher & higher on the Shelves above

them and those that are still inferior in the Drawers under each subdivision."[3]

From the beginning, the British Museum saw its public responsibility as one not only of collecting—building an archive of scientific evidence about the world's natural and artificial creations—but of instructing the public about the world. This entailed organizing and presenting the things collected in ways that were reasonable and that might attract a viewer's attention to the objects in themselves.

This is as true today as it was 250 years ago. Museums still hold as their core mission to collect, preserve, and present things in the public's interest. In presenting them, museums are fully aware of the choices they make. They arrange things in a particular way to draw their visitors' attention to the individual objects and to meaningful relations among objects. They might arrange them according to the era of their manufacture, the cultural region in which they were produced, or the kind of things they are—antiquities with other antiquities, Chinese objects with other Chinese objects, photographs with other photographs—or as a series of focused, thematic exhibitions. Objects tell stories when installed with other objects.

But individual objects tell stories too. They bear the imprint of their making, signs of having been worked by particular instruments and with specific materials: paint strokes, the width and texture of the brush itself, marks of a palette knife, the rubbing of the painter's hand, sometimes the texture of the canvas support or the hard, worked surface of wood. Chemical analysis can help us identify a painting's materials. Infrared reflectography can uncover drawings beneath a painting's surface. Microscopic sectional analysis can show us the order in which paint layers were applied. X-rays can highlight changes to a painting's surface. If a painting is on wood, dendrochronological testing can tell us what kind of wood, the age of the tree when it was cut, where it likely grew, and even whether the panels supporting other paintings now in distant collections were cut from the same tree. Each material and method of manufacture has a history.

Of course a work's subject and stylistic qualities also tell stories. The crucifixion of Christ, the birth of the Buddha, a still life of exotic, natural elements, a street scene, a portrait, the raft of the Medusa, the American flag, a web of poured and dripped lines, the journey of a poet. The art historian Svetlana Alpers reminds us—and she is thinking of the Italian galleries in London's National Gallery—that "the sequence of those paintings—in terms of media, color, and handling and arrangement of figures and settings—resulted from a self-conscious experimental practice [by the artists]. . . . To walk through the rooms was to see that for at least three hundred years those objects constituted a history."[4] And not just a history of their making, but the subsequent history of their reception, ownership, and public display too. Each story, or "history," is implicated in another, and the more we consider an object the more we are drawn into its particular web of histories. As Empson noted in 1759, museums necessarily take this into account when installing their collections.

But just how? To what effect? And at what cost to the experience of the objects themselves? What are the possibilities and limitations of museums in this regard? Questions like these have been asked of museums ever since their foundation, by both museum professionals and their critics. To what extent is or should a museum be *discursive*?

: : :

In 1887 the anthropologist Franz Boas, then a young curator, fretted over the museum's inherent limitations as a discursive site. He criticized the installation of cultural objects laid out in cases like biological specimens—tools of one kind separated from those of another, tools separated from eating utensils, clothing from ritual masks and fire-making materials—independent of their function within a particular tribal culture. Boas argued instead for embedding them in their cultural context: "the ethnological specimen in its history and its medium."[5] He arranged objects and object groups in galleries as an unfolding narrative, numbering them in

a sequence keyed to descriptions printed in an accompanying brochure. He hoped this would discourage visitors from "wandering from right to left without order" and "compel [them] to see the collections in such a manner that they will have the greatest possible benefit from a short visit."[6]

He then supplemented the ordered objects with what he called "life groups," tableaux of costumed figures arranged in dramatic scenes from daily life or rituals demonstrating the purpose and function of particular objects. These tableaux would, he thought, by dramatizing the contexts in which objects had been used, "transport the visitor into foreign surroundings" and, in the words of a recent scholar, "establish a logic of substitution" whereby the visitor was invited "to inhabit the occupation, to phantasmatically enter the scene."[7] But he eventually grew skeptical of this: "All attempts at such an undertaking that I have seen have failed because the surroundings of a museum are not favorable to an impression of this sort. The cases, the walls, the contents of other cases, the columns, the stairways, all remind us that we are not viewing an actual village and the contrast between the attempted realism of the group and the inappropriate surroundings spoils the whole effect." Even the figures themselves, however well cast, painted, and clothed, were of course not real and would inevitably give, he feared, "a ghastly impression such as we notice in wax-figures."[8]

Boas was in a bind. Objects alone, he believed, were insufficient to instruct the museum visitor about culture—"psychological as well as the historical relations of culture, which are the only objects of anthropological inquiry cannot be expressed by any arrangement based on so small a portion of the manifestation of ethnic life as is presented by specimens."[9] And so in 1905 he resigned his curatorial position for a full-time academic appointment at Columbia University.

Some have interpreted Boas's decision to leave the American Museum of Natural History as a sign of the failure of museums in light of greater possibilities in universities. As one university-based scholar put it:

By the first quarter of the twentieth century, objects could no longer hold the meaning with which they had been invested. In an intellectual world now dominated by theoretical and experimental knowledge produced at dynamic and expanding universities, objects, and the museums which housed them, remained static. When the curtain fell on an epistemology based in objects, museums left the center stage of American intellectual life.[10]

Of this same moment, another has written, "The source of knowledge drifted from the halls of the museum to the university's laboratories and libraries. From objects to books. From things to discourse."[11]

: : :

A few years after Boas's shift to the university, the French poet and essayist Paul Valéry wrote that although he found many museums admirable, none was *delightful* because "delight has little to do with the principles of classification, conservation, and public utility, clear and reasonable though they may be"—precisely the qualities Boas held as primary (if in themselves insufficient) to museum work.[12] Valéry disliked the professionalism of museums and the constraints of their protocols ("At the first step that I take toward things of beauty, a hand relieves me of my stick, and a notice forbids me to smoke"). He ached for the intimate, even private experience with an individual work of art and bristled at the conflicting demands of the gallery context. Of sculpture galleries, he wrote, "I am lost in a turmoil of frozen beings, each of which demands, all in vain, the abolition of the others—not to speak of the chaos of sizes without any common scale of measurement, the inexplicable mixture of dwarfs and giants . . . an assemblage of the complete and the unfinished, the mutilated and the restored."[13] His experience of paintings galleries was no better: "A collection of pictures constitutes an abuse of space that does violence to the eyesight." In the sweep of an eye one sees portraits, landscapes, seascapes,

triumphs, and still lifes, assembled with little or no regard to size or adjacent color harmonies, all of which works against the basic truth: that the finer the paintings—"the more exceptional as landmarks of human endeavor"—the more individually they must be experienced.

Valéry wrote from a discerning, personal perspective. He was not concerned with the contributions museums make to scholarship or civic culture. He was only interested in his experience of individual works of art. Museums, he held, displayed too many things and substituted superficiality—and worse, *erudition*—for the profound experience of the thing itself (which required thousands of hours of work, each the result of years of research, experience, concentration, and genius). Museums, he thought, turn works of art into dossiers of information and theories, none of which approaches the depth of meaning and power of affect of the works themselves. For Valéry, the problem with museums was precisely that they *reduced objects to discourse.*

: : :

Boas and Valéry laid out two options for museum display: to emphasize the object in itself or to present it as part of a larger discursive narrative.

Over a weekend in October 1996, the leadership of New York's Museum of Modern Art and select colleagues discussed the same issue—how to balance attention to objects with the presentation and incitement of discourse—as the museum began planning for a major renovation and expansion of its signature midtown building.[14] The question before them, as then chief curator John Elderfield put it, was "How do we best tell the story of modern art?"

MoMA had long been criticized for its insistently sequential presentation of the history of modern art: in the first gallery, Cezanne's *Bather* of 1885, followed, in successive galleries, by Picasso, Matisse, Surrealism, Abstract Expressionism, Pop Art, Minimalism, and Conceptualism. In planning the new building, the museum's director and curators considered various ways of presenting

a more nuanced interpretation of modern art's complex history. Kirk Varnedoe, then chief curator of the Department of Painting and Sculpture, defended the museum's traditional presentation of its collections. "We believe there's an integrity and a wholeness to what we do," he said. "We have a story to tell. We always, in a sense, told a story. When you walk in at that Cezanne *Bather* on any given day in the painting and sculpture collection you can walk out the other end with a synoptic overview of developments in the history of art from Post-Impressionism to roughly the present." But he allowed that there could be new ways of installing and interpreting the collection without losing "the sense of a graspable parade of what we feel are some of the greatest achievements of modern art; that there would be some sense of a mainstream, but that it would be punctuated, adumbrated, expanded, by a series of alternatives in which one might go into greater depth in a particular period."[15] But just how to do this—that was the question. How to tell a complex story, or indeed different stories, about the history of modern art without losing the rigor of its primary trajectory or the visual appeal of the individual object?

The philosopher Mark Taylor questioned the possibility of telling a continuous narrative and proposed that the museum instead consider it as, in his words, "a layered convolution of the discontinuous," occurring in the broader context of globalization and virtualization, which he said was transforming our experience of the world into "some kind of a quasi-dialectical reconfiguration of opposites that is psychologically, socially, and culturally transformative." Just how all of this would translate into a set of installed galleries he didn't say, but he emphasized "that complexity will be the shape of the twenty-first century."[16]

Similarly, the architect Bernard Tschumi was uneasy with the idea that "there can be a cause-and-effect relationship between the sequence of spaces and the narrative that it contains," in which the "spatial movement of the observer's body through the progression . . . [of] gallery spaces has its analogue in the unfolding of time, of the narrative of art, as an unbroken story of interlinked movements, or moments, that culminate in the denouement of the

present." He was more sympathetic to the idea that the history of modern art was one of disruptions and discontinuities, and he fantasized about how that might be given architectural form. "Should it be done literally, through confrontation and conflagration, an explosion of spaces? Or through the creation of a void, a void where everything is possible, an ultimately pliable non-space?" He mentioned that a friend of his once said that a museum should never have a spine but that it might be like a sponge. "What's interesting about this analogy of the sponge," he thought aloud, "is that it suggests the autonomy and the specificity of each of its cells, and also, an endless combination of linkages and of configurations. . . . A sponge is a seamless whole of sorts that preserves the possibility of heterogeneity."[17]

The sculptor Richard Serra had questions about the sponge: was it "equally perforated, or are the connections in the core in closer proximity and the ones in the periphery further apart"?[18] Even in a sponge are there some cells—or *galleries*—that are more important than others? If so, shifting from sponge to museum, how do we encourage visitors to enter those galleries and experience them in some at least reasonably organized way? How do we ensure that the discontinuities a visitor perceives in the unfolding of modern art reflect actual, historical disruptions and are not the result of her own confusion—eccentric or even false views not ruled out by our presentation?

Museum staff can worry about the formal, architectural structure or metaphor underlying their installations—whether it's a spine, a sponge, or, as one participant suggested, a web—but they have to admit that their visitors are likely to experience the museum as they wish. The more curators seek to control their visitors' experience—remember Boas's desire that visitors be "compelled to see the collections in their natural sequence"—the more frustrated their efforts will be. Curators can't even predict how a visitor will experience just one of their galleries: clockwise around the room? counterclockwise? or back and forth, avoiding the crowds in front of the more popular objects, seeking the path of least resistance? As the critic Adam Gopnik said at that MoMA meeting,

It seemed to me that, in fact, your experience of walking through the Museum was that you made up your own story and you did it simply by not paying attention to things that didn't interest you . . . and it seems to me that there's no more grander or more necessary conception that one needs of a museum except that it's a place to go and look at things. . . . The Museum can't be a place where every imaginable story gets told— not because there's no virtue in telling every imaginable story, but because this simply isn't the kind of place where that can happen.[19]

: : :

The art historian Michael Baxandall has reminded us that "it is not possible to exhibit objects without putting a construction upon them."[20] Much recent academic writing on museums has focused on this problematic, in terms of both the constructions museums put on particular objects through strategies of display and the museum itself as an institutional discursive frame.[21]

Take, for example, the writings of art historians Carol Duncan and Alan Wallach. For them, "the museum, like other ceremonial monuments, is a complex architectural phenomenon that selects and arranges works of art within a sequence of spaces . . . [and] organizes the visitor's experience as a script organizes a performance."[22] This "performance" is a secular ritual approaching the religious: "the museum itself—the installations, the layout of the rooms, the experience of collections—creates an experience that resembles traditional religious experiences." By performing this ritual—that is, by simply *walking through the museum*—"the visitor is prompted to enact and thereby to internalize the values and beliefs written into the architectural script."[23] And what is that script? "In keeping with ancient ceremonial monuments, museums embody and make visible the idea of the state"; "in exchange for the state's spiritual wealth, the individual intensifies his attachment to the state." And not just the state, but also "the power and social authority of a patron class."[24]

Tony Bennett, a British-based sociologist, sees the museum in Foucauldian terms, as an instrument of discipline and punishment.

In the nineteenth century, he writes, punishment—now severed from "the function of making power publicly manifest—is secreted within the closed walls of the penitentiary":

> Thus, if the museum supplanted the scene of punishment in taking on the function of displaying power to the populace, the rhetorical economy of the power that was displayed was significantly altered. Rather than embodying an alien and coercive principle of power which aimed to cow the people into submission, the museum—addressing the people as a public, as citizens—aimed to inveigle the general populace into complicity with power by placing them on this side of a power which it represented to it as its own.[25]

Another scholar, Donald Preziosi, sees the chronological installation of objects by national school or civilization (Assyrian, Egyptian, Greek, Roman, medieval, Renaissance, modern—all from a European perspective) as reinforcing the museum visitor's perception that he or she is among the elect and most advanced people: "Chronology becomes genealogy, which in turn becomes evolution and progress, and everything becomes oriented and *arrowed* with respect to its pertinence, its contribution, to the fabrication of the present."[26] As the museum is a seeing experience (where one looks at things), Preziosi figures the museum frame as an "optical instrumentality for the positioning, the siting (and the sighting, the rendering visible, the framing) of modern(ized) populations in and for history that was itself deployed, both museographically and historiographically, as the unfolding of the transcendent truth." In doing so, the museum focuses on the visitor as a *subject of the state* (the museum as "an instrument the size of the state; a vehicle that at the same time contained the state") and from a European perspective, whereby works of art serve as "the most telling products of the human mind, and a universal standard against which all that was not Europe might be measured, graded, and ranked down along the slopes of European modernization."[27]

But that's not all. In Preziosi's view, the power museums have

over their visitors is even deeper, more fundamental and basic, and can only be described in psychoanalytic terms:

> The object can only confront the subject from a place where the subject is not. It is in this fascination with modernity's paradigmatic object — with "art" as such in museological and discursive space—that the subject or spectator is "bound over" to it, laying down his or her gaze in favor of this quite remarkable object. And it is in this fascination that we find ourselves, as subjects, re-membered (repairing our dis-memberment). Museums dis-arm us so as to make us remember ourselves in new ways. Or, to put it another way, museums help us to forget who we are.[28]

They also gender the subject:

> The modern museum of art may also be understood as an instrument of compulsory heterosexuality, one of the chief productions of the institution, after all, is the engendered subject. The typologies of gender positions are among the museum's effects: the position of the museum user ('viewer') is an unmarked analogue to that of the (unmarked) male heterosexual pose/position. So much has been clear; what may be less apparent is that all art is drag, and that hegemonic heterosexuality is itself a continual and repeated imitation and reiteration of its own idealization. Just as the viewer's position in exhibitionary space is always already prefabricated and bespoken, so also is all gender (a) drag.[29]

To these critics, museum installations—and thus museums themselves—are never *not* ideologically motivated and strategically determined. They are always already part of a discursive formation in which discourse is power.[30]

: : :

At this point, one has to ask the obvious: Is this your experience of museums? Do you walk through the galleries of your local museum and feel controlled in any significant way? Do you feel manipulated

by a higher power—in Bennett's terms, an "archactor" and "meta-narrator," the ruling elites of your city, or perhaps the state itself? Do you feel yourself forgetting who you are or being re-membered in new ways or gendered in any way? Is your experience of the museum in any meaningful way ritualistic? Do you proceed in a scripted way through the museum, or even through one of its galleries? Do you even experience the museum in the same way twice?

What about a museum like the Louvre, whose nationalist foundations I have already acknowledged. Carol Duncan sees the Louvre's installation of its collections as converting "signs of luxury, status, or splendor into repositories of spiritual treasure—the heritage and pride of the whole nation."[31] By taking in the museum's collections in this way, one is said to encounter works of art that function as "witnesses to the presence of 'genius,' cultural products marking the course of civilization in nations and individuals." Ultimately, reinforced by ceiling decorations that situate French works of art among the world's most famous, the museum visitor is said to come to see France as the culmination of artistic genius.

We need to be clear: the Louvre is a French national museum. Its director reports not to an independent board of trustees, as does the director of the British Museum, but to the state's Ministry of Culture. We have seen the state's recent manipulation of the Louvre, with its decision—not, at first, enthusiastically endorsed by the museum's director—to open a branch of the museum in Abu Dhabi. It was said that the French government wanted to bring cosmopolitan culture to the Islamic world in order to encourage openness at a time when extremists in the region were proclaiming the incompatibility of Islamic and non-Islamic worldviews. It was also suggested that the French wanted to counter British and American political and military influence in the region (French president Sarkozy inaugurated a new French military base in Abu Dhabi on the same trip that he joined in the groundbreaking for the Louvre Abu Dhabi.)[32] I suspect both motives were present. But does that in any way affect one's experience of the Louvre itself, in Paris, or make it an instrument for defining and glorifying an *essential* French cultural identity?

Do you think that the nearly ten million people who visit the Louvre every year experience it as "the site of a symbolic transaction between the visitor and the state," where "in exchange for the state's spiritual wealth, the individual intensifies his attachment to the state," as Duncan and Wallach would have us believe?[33] Is that your experience? Is your attachment to the French state, assuming you had one in the first place, intensified by looking at the wondrous things from Mesopotamia, Sumer, Akkad, Elam, Susa, New Kingdom and Pharoanic Egypt, Greece and Rome, and Renaissance, Baroque, Neo-Classical, and Romantic Europe as presented in the museum? I suspect, if your experience is anything like mine, your thoughts are on those ancient and distant places, on the people who made those things and looked on them in wonder as you are doing, absorbed by the staggering beauty of those things, perhaps discerning similarities among them, suggestive of a long history of cultural exchange between regions.

Whatever the French state's political ambitions, in my experience the state is absent from one's experience of the Louvre and its collections. It is the *objects* that hold one's attention. And besides, the museum's pyramid entrance—through which one enters, descending to a cavernous central lobby before choosing among four cardinal points of entry and falling into a looking glass maze of galleries—confounds any attempt to script the visitor's experience: visitors to the Louvre, indeed to any museum, wander as they wish from one object that attracts their attention to another. That's one of the great pleasure of visiting museums. As Adam Gopnik remarked in the MoMA session: in walking through the museum, "you made up your own story and you did it simply by not paying attention to things that didn't interest you . . . and it seems to me that there's no more grander or more necessary conception that one needs of a museum except that it's a place to go and look at things."

: : :

Collections of objects acquire new epistemological status as paradigms of knowledge shift over time. The British art historian Ste-

phen Bann proposes that we are presently experiencing a return (he uses the term *ricorso*) to curiosity, that is, to an interest in curious things. Bann likes, as do I, the experience of stumbling upon wondrous things and being taken by them: "Curiosity has the valuable role of signaling to us that the object on display is invariably a nexus of interrelated meanings—which may be quite discordant—rather than a staging post on a well trodden route through history."[34] This seems right to me. And I suggest that curiosity is possible, even inevitable, in any kind of installation that foregrounds the object—gives it room—so that it can be seen easily. In my experience, highlighted presence is enough to trigger curiosity.

Consider a ewer in the collection in the Art Institute (plate 1). Its initial appeal is obvious. Its form is elegant (neck tapering at the drum and flaring at the rim); its surface translucent, made of hard-paste porcelain; its decoration a deep cobalt blue underglaze depicting flowering plum branches and sprays of fruit; and its silver fittings enticing: the dramatic S-shaped silver handle, domed lid with baluster finial, delicate, serrated strapwork, and bold, heraldic phoenix-head spout. The combination of materials is also intriguing: the sheen and elegance of the silver, the hard whiteness of the porcelain, the intensity of the underglaze.[35]

Porcelain might be commonplace today, but it was for centuries a great mystery. The word was first used by Marco Polo in the late thirteenth century to mean both cowry shells and fine pottery: the hard white, lustrous surface of the latter is indeed shell-like (he described it as "very shining and beautiful beyond measure").[36] Early Arab traders first thought that porcelain was made of stone. The fourteenth-century Tangier traveler Ibn Battuta said it was made of clay and crushed stones. As late as the mid-seventeenth century in England it was still thought to be made of crushed shells. It was not produced in Japan until the early seventeenth century and not in Europe until a century later.

Ibn Battuta also reported that it "is carried to India and to the other climes so that it even reaches our country in the Maghreb. And it is the most marvelous of kinds of pottery." Trade in Chinese porcelain was sudden and brisk. Muslim traders worked the mari-

time routes from Egypt through the Indian Ocean and along the sea coasts of Southeast Asia and China. By the early eleventh century, Song-dynasty China, the Chola kingdom in India, and Fatimid Egypt were in regular contact with one other. Early Chinese porcelain has been found from China to Vietnam, India, Sri Lanka, east Africa, the Red Sea, and Egypt. Great collections of it were formed by royal and imperial rulers from India (including the early Mughals, from Timur to Jahangir) to Iran, Egypt, Syria, and Turkey, with the collection at the Topkapi Saray in Istanbul being still one of the greatest in the world (it was built by trade, ambassadorial gifts, and booty: Sultan Selim I's successful campaigns in Egypt and Syria resulted in great transfers of Chinese blue and white ware to the Ottoman capital).[37]

But the trade was not only in Chinese pottery. Early on, the peoples of Vietnam mimicked Chinese blue and white ware to such an extent that the cargo of a single shipwreck off the coast of central Vietnam was found to comprise an estimated 250,000 late-fifteenth-century Vietnamese export ceramics. Much of this kind of material was destined for the Middle East. There it joined Chinese ware, some of which, like a large fourteenth-century Yuan-dynasty dish in the Art Institute (fig. 1), bear Arabic/Persian inscriptions (here on its base), evidence that it was made for the Arab market. The Portuguese arrived in India in 1498 and established a base in Macao in 1514. From there blue and white ware from China and Vietnam made its way westward, around the Cape to Lisbon and from there to northern Europe. A few years later, the Spanish conquered Mexico and from the 1560s were sailing to the Philippines, trading silver for Chinese and Vietnamese blue and white ware, among other things. These goods they brought back to Mexico, transported overland to Vera Cruz, then shipped to Havana and on across the Atlantic to Europe.[38] Some blue and white ceramics remained in Mexico and prompted local imitations like another vase in the Art Institute's collection, this one dating to the early eighteenth century (fig. 2).

The body of the Art Institute's ewer was made in China during the Wanli period of the Ming dynasty near the end of the sixteenth

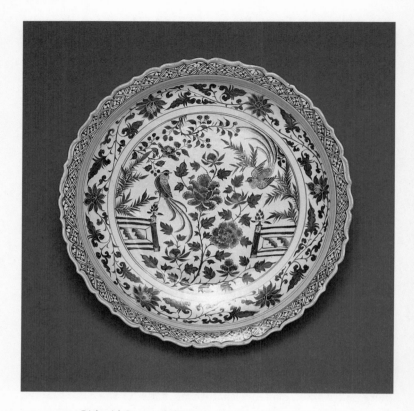

FIGURE 1. *Dish with Long-tailed Birds in a Garden*, Chinese, Yuan dynasty, early fourteenth century, porcelain painted in underglaze blue. Kate S. Buckingham Fund, 1989.84, The Art Institute of Chicago. Photograph © The Art Institute of Chicago.

century, and its silver mounts were added by English silversmiths around 1610. (There are extant examples of blue and white ware enhanced with silver mounts from as early as 1434–1453 in Germany and 1516 in England; a porcelain vase with silver-gilt and enameled mounts is documented in the collection of the king of Hungary in 1381.)[39] Its form derives from a drinking vessel known as a *kendi*, which itself was a variation of the *kundika*, which had emerged in India by at least the third century BC and was originally used to sprinkle water in Buddhist ceremonies of purification. (Note the

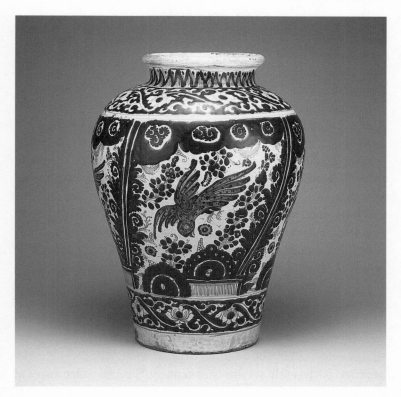

FIGURE 2. Vase, Talavera Poblana Puebla, Mexico, 1700–1750, tin-glazed earthenware. Gift of Eva Lewis in memory of her husband, Herbert Pickering Lewis, 1923.1445, The Art Institute of Chicago. Photograph © The Art Institute of Chicago.

bulbous protuberance under the silver, dome-shaped spout base: that was the original spout.) With Buddhism, the *kundika* made its way to Southeast and East Asia. It is likely that the Art Institute's ewer was made by Chinese porcelain artists for the Indonesian market and may have made its way to Persia by way of the Indian Ocean, where such objects were adapted for use as *kalians*, or water pipes. By the early 1600s it got to England, perhaps with the aid of the East India Company, where it was enhanced with silver fittings to adorn a table in the home of a wealthy Jacobean collector.

What can one make of the ewer, seeing it in the museum's gallery? We can see that it is beautiful. That it betrays centuries of international cultural contact. That its manufacture and decoration required sophisticated technologies. That these technologies and the subsequent trade that brought the ewer from China to London required large outlays of capital. We know the history of early maritime trade and the rise of British imperialism. We know the place of such objects in early modern domestic, decorative ensembles. We can imagine it with other silver wares, blue and white ceramics (those made in the East and closer to home, in Delft), Persian carpets, dark wooden tables and turned chairs and stools, brass candelabra with candles, and brocades. We are intrigued by its adaptive reuse and reflect that it exemplifies the human tendency to transform inherited things for one's own purpose and delight because as humans we are compelled to improve our world by making it anew.

Does it matter then where we see it, in one gallery or another? After all, it could be shown in any number of groupings: among Chinese objects or European objects, with other blue and white ware from around the world, with other pouring vessels, with other things enhanced by the addition of other materials, or with other products of the early seventeenth century. Need our experience of it be compromised by that fact that it can be exhibited in only one place, one context, at a time? No longer, not with all of the verbal, acoustical, and visual supplements at hand (labels, audio guides, photographs; all three perhaps on a digital monitor). And not when we can (or will soon be able to) download the object's curatorial file onto our PDAs right there in the gallery, e-mail the file to our home accounts, collate it into a larger file with links to other relevant objects in the collections of this and other museums, along with their curatorial files and the bibliographic sources cited in each. There is no end to discursive contexts that can be given to an object in a museum gallery, whether suggested by the museum or devised by the visitor herself. But it all starts with the object. As Nabokov wrote, "When we concentrate on a material object, whatever its situation, the very act of attention may lead to our involuntarily sinking into the history of that object." *Things first, then discourse.*

: : :

In a profound way, the museum experience is a critical one, which is to say it begins by seeing the object—in the case of art museums, the work of art—as in itself it really is and not as our predilections and prejudices think it to be. The opportunity to look hard and long at works of art, to have our first impressions changed and deepened, our expectations challenged and rearranged, reconciled to the works on display, is the promise of art museums. The works of art preceded us. Experiencing them, as they are, requires that we put aside our self-centeredness. And this is good, in the sense put forward by the English moral philosopher Iris Murdoch when she said, "Anything which alters consciousness in the direction of unselfishness, objectivity and realism is to be connected with virtue." (Lionel Trilling said something similar when writing about objectivity: "Objectivity, we might say, is the respect we give to the object, as it exists apart from us. . . . In the face of the certainty that the effort of objectivity will fall short of what it aims at, those who undertake to make the effort do so out of something like a sense of intellectual honor and out of the faith that in the practical life, which includes the moral life, some good must follow from even the relative success of the endeavor.")[40]

The museum's call is to objectivity. Discursive displays are contrived by secondary agents: us, curators, critics, historians who strive for objectivity but inevitably fall short. What is so surprising about the writings of the museum critics cited above is how little regard they have for the individual agency of the museum visitor. They imagine her as unwittingly subject to the ideological strategies of the museum, and through the museum to those of the state and the political and social elite. She has no independence of mind and cannot see through the discursive structures employed by the museum in the display of its collection or presentation of its exhibitions. She has no means of being objective herself. Just how these writers escape the control of the museum, why they can see through the apparatus of power to write critically about it when *she can't*, is not clear. If they can do it, why can't she and everyone else?

The theorist of modern liberalism Alan Wolfe has written that liberalism's greatest contribution is that we are what we create through our own deliberative acts.[41] As liberal institutions, museums respect individual agency. We expect our visitors to determine their own experience. They bring to the museum a range of preparedness, with specific interests, curiosities, and assumptions about what they are going to see. They go where they want to go, in any order they choose. They linger over what they like and ignore what they don't. They read the well-intentioned labels or they don't. They might accept the offer of an audio guide or they might not. They stay as long as they want and they leave. We hope they find something to interest them as they go through our galleries, and we present our collections accordingly. We offer assistance, a simple framework for getting around. In the case of the Art Institute, it's a combination of geographical, chronological, and typological organization: European paintings, sculpture, and decorative art from the medieval period through the nineteenth century, not far from European and American prints and drawings, just across from Japanese prints, next to other Japanese, Korean, and Chinese works of art, then on to the art of the Himalayas, South and Southeast Asia, before the art of the Islamic lands and the ancient Mediterranean world, and then modern and contemporary art, photography, architecture, and design. Or the reverse, or in any other order. The museum visitor can choose her route. If inclined to make a "script" of her experience, she will write it herself.

What our visitors can't provide for themselves, of course, is what they find in our collections. Over the years, our collections have been built by curators working on behalf of the public. We have only the collections we have. We make no pretense to completeness. But we strive to be encyclopedic, to present representative examples of works of art from most of the world's cultures. And we try to present them in ways that foreground their individual appeal, without privilege or prejudice with regard to where and by whom they were made (contrary to Preziosi's presumption that non-European works are "measured, graded, and ranked down along the slopes of European modernization"). We want our visitors to experience

the works of art on view in our galleries individually, to let each one elicit a critical—*objective*—response, which can then be carried to a neighboring work of art or one in some distant gallery. Visitors are encouraged to draw connections between objects. But we can't make this happen. It is their experience, not ours. They will or will not experience what Stephen Greenblatt calls the experience of "wonder" or "resonance." (Wonder he defines as "the power of the displayed object to stop the viewer in his or her tracks, to convey an arresting sense of uniqueness, to evoke an exalted attention"; resonance as "the power of the displayed object to reach out beyond its formal boundaries to a larger world, to evoke in the viewer the complex, dynamic cultural forces from which it has emerged and for which it may be taken by a viewer to stand."[42]) But we work to afford them the chance to do so, by simply doing what James Empson was already doing at the opening of the British Museum 250 years ago: organizing and presenting our collections publicly in reasonable ways and in ways that might attract visitors' attention to the objects in themselves.

My understanding of art museums is simple, and I share it with Svetlana Alpers: museums "provide a place where our eyes are exercised and where we are invited to find both unexpected as well as expected crafted objects to be of visual interest to us."[43]

Some will no doubt see this as insincere or naïve and woefully undertheorized. In turn, I deem their critiques fantasy, projections of their own intellectual predilections for theories and arguments built on rhetoric rather than evidence. As Carol Duncan admits, "I have no findings to report about how an 'average' or representative sample of visitors reads or misreads museums. The 'visitors' I am after are hypothetical entities—ideal types implicit in the museum's galleries."[44] In other words, she does not want to have individual visitor responses disrupt or complicate her interpretation of what museum galleries mean or what "script" they follow—a script, one can argue, that is written by Duncan and imposed on such "ideal types" as might populate the galleries she imagines. Duncan and her colleagues see a discursive museum where I see an Enlightenment one. They see museums as ideological instruments

of political and social power in which objects are but agents of a master narrative. I see museums as public places of individual experience. They deny individual agency. I respect and encourage it. Where they are postmodern and statist, I am modern and liberal. I hold fast to the principles of individual autonomy, permanent critique, opposition to dogmas and formulas, and the public use of reason. I see these as forming the basis of museum work: to put works of art before our visitors in a manner both reasonable and attractive, and to pursue incessant research into the history of the objects under our care. Nothing in my experience of museums suggests this is not the case.

This is not to suggest that I don't have higher hopes for the consequences of objective, critical experiences with a diverse range of individual works of art. On the contrary. I argue that such experiences hold promise for the discovery of truths about the world—not a single, universal truth but many truths, each offered up in the spirit of Kantian critique and Trillingian criticism as a thesis to be reconciled with individual objects (facts) as in themselves they really are. And what *they really are*, as we have seen with the Art Institute's blue and white ewer, are mélanges or hotchpotches of cultural influences, evidence of the truth about culture as always hybrid, always bearing witness to the cross-currents of human contact, always impure and mongrel, always arguments against the political instinct to essentialize culture and claim it for oneself, as that which defines one's nation and distinguishes it indelibly from any other.

I will have more to say about this—about translation and hybridity—in the next chapter. Let me end here by stating simply that encyclopedic museums are a means of dissipating ignorance about the world and promoting inquiry and tolerance of *difference* itself. The founders of the Art Institute assumed that the museum—as a public space and encyclopedic collection—would contribute to the formation of a common civic identity among Chicago's polyglot, multiethnic population. They did not prescribe what that identity would be, other than Chicago's. They did not write a *script* for the visitor's experience. Like Empson, they wanted only to present the

museum's collection clearly and with the expectation that by draw-
ing the city's diverse population together and creating a context for
the shared critical experience of works of art, they were encourag-
ing cultural understanding among Chicagoans. In this, they were
heirs to their Enlightenment predecessors, who, like Hume, railed
against the specialization and professionalism of knowledge and
scientific inquiry and, like Sir Hans Sloane, founded a public en-
cyclopedic museum to be "as useful as possible, as well towards
satisfying the desire of the curious, as for the improvement, knowl-
edge and information of all persons" and "for the general Use and
Benefit of the Public."

Providing public access to works of art representative of the
world's many cultures "under one roof," and in so doing contribut-
ing to the vitality of the public sphere and the strengthening of civil
society by encouraging the "public use of one's reason," is what
museums do. That is a lot. And it is enough.

The Cosmopolitan Museum

I prefer the edge: the place where countries, communities, allegiances, affinities, and roots bump up against one another—where cosmopolitanism is not so much an identity as the normal condition of life.

TONY JUDT[1]

Ibn Battuta, the Tangier traveler who remarked upon the trade in Chinese porcelain ("it is carried to India and to other climes so that it even reaches our country in the Maghreb"), was born in 1304. In 1325 he undertook his first hajj, crossing North Africa and passing through Palestine to Syria before turning south to Mecca. Over the next several years he traveled to Iraq and Persia and down the east coast of Africa as far as present-day Tanzania, returning between trips to Mecca. In 1330 he left for India, traveling by way of Syria, the Black Sea, and west Central Asia—with a detour back to Constantinople—then eastward through Afghanistan to the Indus valley and the court of Sultan Muhammad bin Tughluq in Delhi. In 1341 he led a diplomatic mission to China, only to be shipwrecked; he spent the next few years in southern India, Ceylon, and the Maldive Islands, and in 1345 again set out for China, sailing by way of Burma and Sumatra, then up the coast of Vietnam. A year later he returned to Mecca and in 1349 to Tangier. During the next five years he traveled within Morocco, to the south of Muslim Spain, and by camel caravan across the Sahara to Mali. In 1355 he returned home,

where the Sultan Abu Inan Faris commissioned a record of his experiences and observations, now commonly known as the *Rihla*.[2]

For the greater part of thirty years, Ibn Battuta traveled throughout the *Dar al-Islam*—literally, "house of Islam"—as a member of the "literate, mobile, world-minded elite, an educated adventurer, as it were, looking for hospitality, honors, and profitable employment in the more newly established centers of Islamic civilization."[3]

During the fourteenth century the Islamic world was as large and diverse a "community" as any on earth, extending from Morocco to India and Southeast Asia, and Ibn Battuta traveled some seventy thousand miles within it. Historians have termed it "transhemispheric."[4] It was, the political scientist Roxanne Euben has written, "a highly cosmopolitan civilization [occupying a] loosely linked territory through which a remarkable array of peoples moved and interacted without the hindrance of the fixed borders of the modern nation-state" and "signaled not cultural or linguistic homogeneity but a common framework of faith in which radical heterogeneity flourished."[5] It was not a world of a singular identity but a crossroads of multiple and mixing ones, what the social scientist Bamyeh Mohammed has called a heteroglossic global society characterized by "unity imagined" rather than "disunity proclaimed."[6]

I raise this here, and recall Ibn Battuta, because I am interested in the way travel and travel accounts—from Herodotus to Xuanzang, from Thesiger to Naipaul and Kapuścínski—can broaden, deepen, and confound our sense of the world.[7] Some travelers experience a radical detachment and wander rootlessly. Others, at least initially, find their sense of self threatened and retreat into the familiar, to which they cling blindly even as they encounter new places. Still others come to recognize the common nature, fate, and identity of all peoples, however different their cultural and racial appearances. In every case, and at the very least, travel challenges our tendency to essentialize cultural differences and see cultural purity where none exists. As the philosopher Paul Ricoeur has written, "When we discover that there are several cultures instead of just one and consequently at the time when we acknowledge the end of a sort

of cultural monopoly, be it illusory or real, we are threatened with destruction by our own discovery. Suddenly it becomes possible that there are just others, that we ourselves are an 'other' among others."[8] This he sees as a positive thing, as do I.

I am speaking here of voluntary travel one embarks on willingly (I will have more to say about involuntary travel below). And I want to suggest that such travel is akin to walking through the galleries of an encyclopedic museum (which of course one does voluntarily). In the museum one comes upon new and strange things, works of art from different times and places that resonate with each other in perplexing ways and compel one to give narrative shape to one's experience of them. Take, for example, a pair of sculpted heads from the collection of the Art Institute: one, extraordinarily evocative, in plaster, with open mouth, blank eyes, and flaring curls (fig. 3), the other a dark, rubbed, quietly expressive, elongated form (fig. 4). What does one make of their similarities, differences, variations? Does one locate an answer to these questions in their cultural or formal differences? Or in the similarities that overcome such differences?

The narrative one constructs in coming to terms with the new and different is in some ways like a traveler's account. In Euben's terms, such narratives illustrate "how a sense of home and other is produced and transformed through shifting sets of nested polarities . . . that are plastic, contingent, and persistent. . . . The continual traction and mutability of these polarities suggest that home and away, self and other, familiar and foreign are 'not an instant property or possession' but rather emerge, transform, and recede in the course of the journey itself, much like the flow of a river nested between solid embankments."[9]

I argue that this is the true "script" or narrative account of the museum experience, one written not by the museum but by the visitor herself as she travels from object to object, drawn by what catches her attention and provokes her curiosity. Such self-directed pursuit of interesting things has the potential, like travel, to increase the visitor's appreciation of the intertwined histories of cultures.

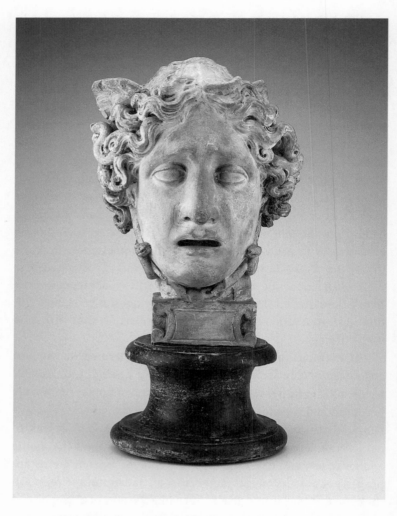

FIGURE 3. Antonio Canova, *Head of Medusa*, ca.1801, plaster. Lacy Armour Endowment, 2002.606, The Art Institute of Chicago. Photograph © The Art Institute of Chicago.

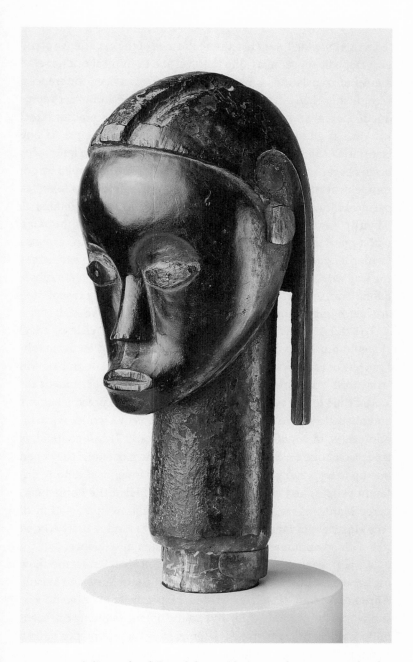

FIGURE 4. Reliquary head, Fang Gabon, mid-nineteenth century, wood and copper. Frederick W. Renshaw Acquisition Fund, Robert Allerton and Ada Turnbull Hertle endowments, Robert Allerton Income Fund, and the Gladys N. Anderson Endowment, 2006.127, The Art Institute of Chicago. Photograph © The Art Institute of Chicago.

In this chapter, I want to explore the idea of the experience of the encyclopedic museum as akin to travel and to think about travel as a term of translation, a means of mediating between differences, recognizing that a translation is never a simple and exact reproduction of meaning because the terms in question are not fixed, nor does it eliminate the differences between the terms. As one translation theorist has written, "The mongrelization of languages occurs because their 'interiors' and 'exteriors' are separated by porous, elastic membranes and not by rigid walls; [but] despite such a permeability of boundaries, each language heuristically retains its 'identity' in relation to other languages."[10] This seems right to me with regard to works of visual art. A work of art made in response to another does not eliminate the source object but forever changes the way we see it as we carry back to it our experience of its subsequent "translation." The two—the inspiration and the response—are hence forever linked and mutually enhanced, as we shall see.

The linking of travel, translation, and the experience of encyclopedic museums holds promise for encouraging a cosmopolitan view of the world. As Edith Grossman has written, translation "transforms the foreign into the more familiar and permits us for a brief time to live outside our own skins, our own preconceptions and misconceptions. It expands and deepens our world, our consciousness, in countless, indescribable ways."[11] This, I contend, is true also of one's experience of encyclopedic museums: they open one up to a greater appreciation of a "unity imagined" among different peoples and cultures of the world, of what the Roman emperor Marcus Aurelius called the cosmopolitan appreciation of "the closeness of man's brotherhood with his kind; a brotherhood not of blood or human seed, but of a common intelligence."

We will see that this is not an uncontested idea. But let me show my hand by siding with the philosophers Richard Rorty and Kwame Anthony Appiah, who have written, respectively, "We see no reason why either recent social and political developments or recent philosophical thought should deter us from our attempt to build a cosmopolitan society," and "People are different, the cosmopolitan knows, and there is much to learn from our differences."[12] I suggest

that encyclopedic museums are sites for such learning and are, at their very foundation, cosmopolitan institutions.

: : :

Roxanne Euben is interested in travel and travel accounts as "a search for knowledge." She recognizes, however, that this is not an innocent pursuit, or one equally available to everyone. For in our age of "porous borders, portable allegiances, virtual networks, and elastic identities [that] now more than ever evoke the language of mobility, contingency, fluidity, provisionality, and process rather than that of stability, permanence, and fixity . . . such encounters [as result from travel] often proceed under conditions of radical inequality between and within regions, cultures, nations, and transnational and subnational communities."[13] This is the character of the postcolonial world in which we live. I will return to this in chapter 4. I want now only to include these conditions in the search for knowledge that informs travel (and the experience of encyclopedic museums) and that allows one to see difference and inequality for what they are: the result of the complex formation of the world's cultural, economic, and political relations.

As I mentioned, there is both voluntary and involuntary travel: tourists, merchants, and scholars, as well as slaves, migrants, and refugees. This in itself is of interest with regard to encyclopedic museums. Take the plaque shown in figure 5. It was forcibly removed from the West African kingdom of Benin in 1897 by British troops seeking retribution for the deaths of their colleagues. Its irregular shape and rough edges betray the violence of its removal. Our narrative response to this object's appearance must take into account its place in the history of a particular imbalance of power at the end of the nineteenth century, when the British Empire controlled much of the trade and exercised great influence over political relations in this part of West Africa.

But one also marvels at the quality of the plaque's production, as both artistic form and technical achievement. Such workmanship in bronze and brass was the result of centuries of technical re-

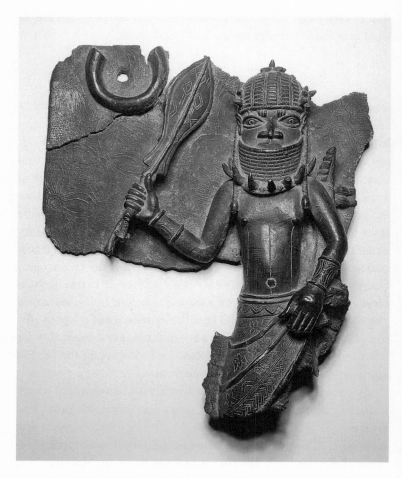

FIGURE 5. *Plaque of a War Chief,* Edo, Court of Benin, Nigeria, sixteenth/ seventeenth century, brass, Samuel P. Avery Fund, 1933.782, The Art Institute of Chicago. Photograph © The Art Institute of Chicago.

finement and required a concentration of capital that, when these objects were first brought to Europe (following their removal by the British), caused considerable consternation. How could such "primitive" peoples as Africans produce such beautiful and accomplished metalwork?[14] One is drawn to the figure depicted on the plaque: a courtier carrying an *eben,* or ceremonial sword, which he

would toss and twirl in court rituals before the king and his ances-
tral shrines as an act of fealty. The Benin kingdom was a warfar-
ing power, and war was the force behind its empire building from
the second half of the fifteenth century until the conquest by the
British four hundred years later.[15] This plaque was no stranger to
violence—not in its production through fire, its role in a bellicose
culture, nor the confrontation with another empire that led to its
removal (one empire confronting the remnants of another). All of
this—and the many meanings of displacement—must be consid-
ered when coming upon it in a museum gallery.

Take another object: a talismanic textile probably made in Sen-
egal in the late nineteenth or early twentieth century (plate 2).[16]
Islam had extended into West Africa as early as the beginning
of the eighth century by way of trade and commerce with North
Africa, which it had reached a century earlier. Among Islam's many
contributions to the history of Africa along the trans-Saharan
trade routes was the introduction of written script. Many Muslim
scholar-merchants would come to serve as advisors and scribes for
local kings, thus helping to administer their kingdoms. And with
script and the ability to read it one could teach the Qur'án. (Much of
what we know of the early history of Islam in West Africa, we know
from early travel accounts like that of Ibn Battuta, who traveled the
trade routes to Mali in the early 1350s.)

In Sufism, the form of Islamic mysticism dominant in Senegal,
repetition of verses of the Qur'án is a form of devotion. This tex-
tile is covered with Qur'ánic verses in Arabic script, which were
likely recited as they were inscribed. The calligraphy is arranged in
a checkerboard pattern around shapes, also checkered, that evoke
magic squares and arrangements of numbers that Sufis believe
reflect divine mystery. Amulets encasing small squares of folded
paper bearing sacred writing (verses from the Qur'án, other reli-
gious texts, or magic squares) are attached. The portability of this
textile, which could be easily folded and carried from village to vil-
lage and worn by holy men in Sufi ceremonies, suggests the spread
of Islam along trade routes west from Arabia across Africa, as well
as the nature of its ritual practices. Any consideration of this evoca-

tive object must take into account the dissemination of Islam and its role in trade and subsequent political relations, together with specific Sufi practices.

Or yet another object: a *thangka* that tells a tale of the transmission of Buddhism from northern India into Tibet (plate 3). Easily rolled up and carried by monks from monastery to monastery, it represents the Buddha as the master of medicine and the teacher of healers, Bhaishajyaguru (or Menla, in Tibetan).[17] Seated in meditation on a lotus, the Buddha wears a stylized monk's robe. His blue coloring refers to lapus lazuli, which was believed to cure the three poisons—desire, hatred, and delusion—and was historically valued for its rarity and purity. He is flanked by two bodhisattvas (Suryaprabha on his right, Chandraprabha on his left), enlightened beings who choose to stay in the cycle of death and rebirth as spiritual guides to mortals. The numerous other figures include other Medicine Buddhas, bodhisattvas, protective deities astride animal mounts (deriving from Hindu deities), and Tibetan wealth deities along the bottom. Just beneath the Buddha is a representation of Padmasambhava, the renowned Indian monk who was invited to Tibet by King Trisong Detsen near the end of the eighth century to teach the Buddhist scriptures and is the founder of the Nyingmapa sect of Tibetan Buddhism. By meditating on each of these many figures, Buddhist devotees would contemplate the totality of the Buddha's healing virtues, while we, perhaps, in the secular context of the museum, are drawn more to the phenomenon of the transmission of ideas, of Buddhism into Tibet, first from India but then not long after from China (in the form of Chan Buddhism), and then, with the Chinese occupation of Tibet in 1959 and the exile of the Dalai Lama, from Tibet to the West.

We could go on. We have seen the role of travel and translation in the story of the blue and white ewer (plate 1). Most every object has such stories. Some are fairly simple, like the tale of cultural tourism told by John Singer Sargent's *The Fountain at Villa Torlonia, Frascati, Italy,* 1907 (fig. 6), which depicts the American painter Jane de Glehn painting with her English painter-husband, Wilfrid, while on tour in Italy. Others are more complex, like the powerfully

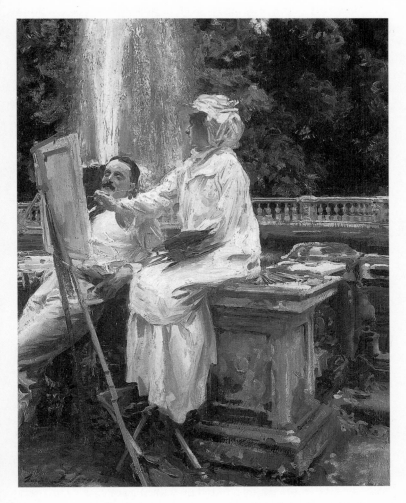

FIGURE 6. John Singer Sargent, *The Fountain, Villa Torlonia, Frascati, Italy*, 1907, oil on canvas. Friends of American Art Collection, 1914.57. The Art Institute of Chicago. Photograph © The Art Institute of Chicago.

encoded story of imperial legacy seen in this Ghandaran sculpture of a bodhisattva (fig. 7), which represents the complex synthesis of Hellenistic, Indian, and Central Asian influences, evidence of Alexander the Great's conquest of Ghandara (a region bordering the Hindu Kush in present-day Afghanistan) following his defeat of the Persian Empire in 330 BC, but also his invasion of and ultimate reversal in India three years later.

The point is simple: as we saw in the last chapter, objects tells stories, and most tell stories related to travel, dislocation, transmission, and translation (the Ghandaran bodhisatttva's Hellenistic elegance and musculature and the opulence of his jewelry recalling—*translating*—the regal conventions of an Indian prince). Such objects are as mongrel as languages. Wandering from object to object and gallery to gallery in an encyclopedic museum opens one's curiosity to the complex histories of cultural relations and to the workings of artistic translation among them.

: : :

Let us now consider a more recent example. In 1990 the Art Institute purchased *Zen Studies*, a set of six etchings by the contemporary American painter Brice Marden (figs. 8 and 9).[18] Over the course of the prior six years, Marden's work had changed from a singular focus on monochrome panels made of oil and terpineol on canvas (these had been preceded by monochrome panels made of oil and beeswax on canvas, in all some twenty years of exploring the rich possibilities of scale and combinations of deeply saturated color areas) to more thinly painted oil paintings of cursive imagery inspired by Chinese and Japanese calligraphy.

In 1983 and 1984 Marden traveled in Thailand, Sri Lanka, and India. It was a journey and a pilgrimage. Back in New York, he went to an exhibition of Japanese calligraphy at the Asia Society.[19] Over the next two years he read Chinese poetry in translation, especially the work of the Tang-dynasty, Cold Mountain hermit Han Shan. An edition translated by Red Pine included the original poems typeset in Chinese characters on the left-hand pages, with English transla-

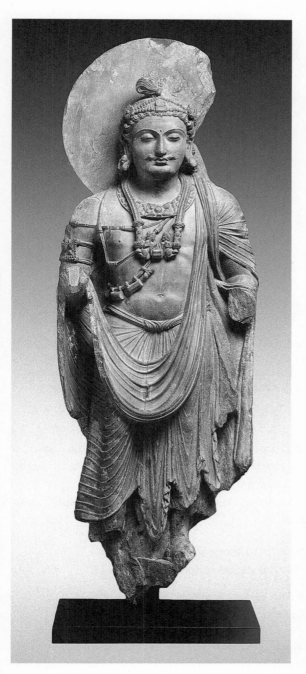

FIGURE 7. *Bodhi-sattva*, Pakistan, Gandharan region, second/third century, Phyllite. James W. and Marilynn Alsdorf Collection, 198.1997, The Art Institute of Chicago. Photograph © The Art Institute of Chicago.

FIGURE 8. Brice Marden, *Zen Studies*, plate 1 from *Cold Mountain Series*, 1990, etching and aquatint on white wove paper. Restricted gift of Mr. and Mrs. Roy Friedman, Mr. and Mrs. Ralph Goldenberg, and Mr. and Mrs. Lewis Manilow, 1990.504.1, The Art Institute of Chicago. Photograph © The Art Institute of Chicago.

tions on the right. Marden has said that it was with this book that he first began to consider Asian characters as more than calligraphy—as language and not just visual markings.[20]

The spare, searching beauty of Han's poetry was deeply inspiring to Marden:

> Springs flowing pure clarity in emerald streams,
> moonlight's radiant white bathes Cold Mountain.
>
> Leave wisdom dark: spirit's enlightened of itself.
> Empty your gaze and this world's beyond silence.[21]

Although not a Buddhist, Marden was reading in and about Zen. He found its commitment to striving for perfection—enlighten-

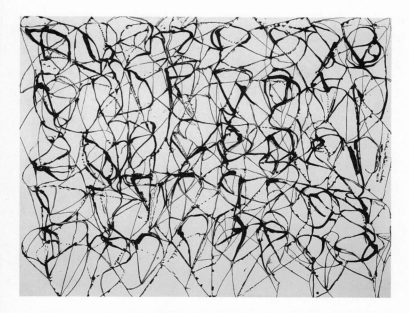

FIGURE 9. Brice Marden, *Zen Studies*, plate 3 from *Cold Mountain Series*, 1990, etching and aquatint on white wove paper. Restricted gift of Mr. and Mrs. Roy Friedman, Mr. and Mrs. Ralph Goldenberg, and Mr. and Mrs. Lewis Manilow, 1990.504.3, The Art Institute of Chicago. Photograph © The Art Institute of Chicago.

ment—helpful to his working: "If I was concerned about getting there [perfection], I would choose a likely method—whether Zen or something else—and I would do it. I guess in a way I have chosen my method, and my method is painting."[22]

In 1986 Marden began working on a series of twenty etchings published as *Etchings to Rexroth* (he had been reading Kenneth Rexroth's translations of the eighth-century, Tang-dynasty poet Tu Fu; the etchings were published separately, in portfolio form, and then in a limited-edition letterpress book with thirty-six translations by Rexroth).[23] The etchings roughly "translate" Chinese characters, inasmuch as their increasingly intricate skeins of black lines look calligraphic. A group of twelve paintings from 1987–1988 explored these visual relationships on much greater scale. And then

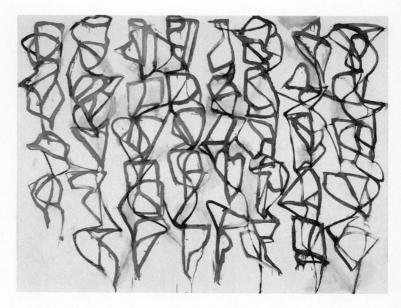

FIGURE 10. Brice Marden, *Cold Mountain 1 (Path)*, 1988–1989, oil on linen. Private Collection, courtesy Matthew Marks Gallery. © Brice Marden/Artists Rights Society, New York. Courtesy Matthew Marks Gallery, New York.

later in 1988, Marden began a series of paintings he called "Diagrammed Couplets," or simply "Couplets," which took the form of two side-by-side vertical columns of five forms each (which he calls "glyphs").

A year later, Marden painted *Cold Mountain 1 (Path)* (fig. 10), its title referencing Han Shan, and its imagery comprising eight columns (or four "couplets") of five glyphs painted with black oil paint on a white primer ground, working from top to bottom and, like Chinese writing, right to left.

He thought of it as an unfolding narrative—"I was thinking in terms of a calligraphic handscroll"—which one would experience and similarly be a witness to. He wanted it to retain the freshness of his contemporaneous drawings—to be "more directly involved in the act of drawing and the automatic"—to be layered with a rhythm of observation and automatic response. One sees this lay-

ering in the crossing of lines that weave one glyph and column of glyphs into another and in the addition of darker lines that read as if slightly in front of the lighter gray lines, giving the overall picture the look of a cat's cradle (nascent here, much more pronounced in his subsequent *Cold Mountain* paintings).

As he was working on his *Cold Mountain* paintings, Marden was also making *Zen Studies*, the series of etchings the Art Institute acquired in 1990. He was interested in the development of each etching—the progressive "states" as he added webs of lines over earlier lines—and as he worked on the *Cold Mountain* paintings, he came to think of their stages of development as similarly distinct states. He photographed the paintings in progress at roughly one-year intervals, allowing one to see the pictures' gradual construction. The evidence of earlier stages is still visible in subsequent states, as lighter, "ghost" lines beneath those added later.[24]

Marden made the pictures by standing five feet from the canvas and leaning in with an extended brush, painting each glyph in a single, continuous stroke. With a knife, he then scraped off the paint (often scraping numerous times), applied brush and paint again, and scraped some more, stepped back from the canvas, considered his next move, painted again, scraped, and with a terpineol-soaked paper towel rubbed out a line or part of line, correcting and erasing lines almost as often as he made them. "One of the things I wanted to do in these *Cold Mountain* paintings," he has said,

was to lose myself in the same way that I lose myself when I am drawing. A drawing is not terribly threatening. There's an ease to the scale and to the material. In a drawing I am not as concerned about where everything's going—and by that I mean not just where I am headed with the drawing but also more literally where every mark is going to go on the paper. Because of that freedom from concern, the decisions can be more automatic, more gestural, less thought out, and that's when drawing, for me, becomes a meditative state.[25]

Marden acknowledges the influence of Chinese calligraphy on his *Cold Mountain* drawings, paintings, and the related etchings:

These are not pictures of specific places or things. . . . It's not a form of writing. I'm *not* trying to make a language. I think of Chinese calligraphy as simply the way I see it, not knowing the language. . . . But if someone translates a piece for me, and I hear the relationships, I am affected by that. I use the form of calligraphy, then it disappears, but, it's always there, in some way.[26]

He also acknowledges a debt to Chinese painting:

The [*Cold Mountain*] drawings now look more like Chinese landscape and less like calligraphies . . . they're about particular places and inspirations—the Magic Mountain's. For me, drawing is about the state that the person would be in who's standing in the drawing looking at the mountain, it's about sensing that. I find that interesting about the Chinese. . . . [Their] paintings and drawings evolved in a kind of inspired state . . . there's usually somebody in the picture undergoing some sort of experience, or on a pilgrimage towards an experience.

At the time Marden was particularly interested in the paintings of the fourteenth-century Yuan-dynasty painter Ni Zan.[27] Like Han, but for different reasons, Ni was a wanderer. His paintings typically record his responses to an empty landscape: a group of trees in the foreground and a mountain in the distance; each image painted in dry brushwork with subtle variations "to reveal changes in his circumstances and state of mind," with "the effect of dematerializing the materials of the painting, purging them of ponderousness."[28] On one painting, he inscribed:

On the riverbank, the evening tide begins to fall;
The frost-covered leaves of the windblown grove are sparse.
I lean on my staff—the brushwood gate is closed and silent;
I think of my friend—the glow is nearly gone from the hills.[29]

There is the sense of wandering in Marden's *Cold Mountain* paintings (his first is titled "Path," the fifth "Open," and the sixth "Bridge"; the others are untitled). While their lines are material routes taken by the artist in the making of the pictures, their down-

ward, flowing rhythms are like river water flowing over rocks, their loops like small pools and eddies.

Calligraphy and painting have a long, shared history in Chinese art. They are two of the "three perfections" (the third being poetry, which of course was often inscribed on a painting). The scholar-painter Zhao Mengu was not only a revered painter but the leading calligrapher of his time. And like the younger Ni Zan, he often included inscriptions on his paintings, inviting the comparison of image-making to writing.[30]

Chinese painting often took the form of handscrolls in which image and writing alternate to tell a story as the scroll is unrolled. When the handscroll painting is a landscape, "the viewer," as James Cahill has written, "takes an imaginary journey through a continuous terrain."[31] We know that Marden was thinking of a handscroll and its narrative form when he painted his first *Cold Mountain* painting. Looking at *Cold Mountain 2* (plate 4), with its washed and coursing lines conjuring mist and undulating mountain paths, one recalls the poetry he was reading at the time:

> If you're climbing the Cold Mountain Way.
> Cold Mountain Road grows inexhaustible:
>
> long canyons opening across fields of talus.
> broad creeks tumbling down mists of grass.
>
> Moss is impossibly slick even without rain,
> but this far up, pines need no wind to sing.
>
> Who can leave the world's tangles behind
> and sit with me among these white clouds?[32]

The painting is not an illustration of this or any particular poem, but rather a *translation* of Marden's engagement with Chinese poetry, painting, and calligraphy (as well as the paintings of Jackson Pollock, always a touchstone for Marden). There is no one-to-one correspondence between his paintings and any of (or even any parts of) the other works, but collectively the latter deeply informed his *Cold Mountain* project and as such are evident in "the

linguistic charge, the structural rhythms, the subtle implications, the complexities of meaning and suggestion in vocabulary and phrasing, and the ambient, cultural inferences and conclusions those tonalities allow us to extrapolate," which the translator Edith Grossman regards as central to the work of translation.[33] "Words *mean*," Grossman writes, "as indispensable parts of a contextual whole that includes the emotional tone and impact, the literary antecedents, the connotative nimbus as well as the denotations of each statement."[34] This is true of works of visual art as well. The contextual whole ("connotative nimbus") of which Marden's *Cold Mountain* paintings, prints, and drawings are a part is indexed in their imagery, cursive linearity, emotional register, and *meaning*.

Grossman has written thoughtfully about why translation matters; not only because, as I noted earlier, it "permits us for a brief time to live outside our skins," but also because it enriches the nature of language itself:

> The more a language embraces infusions and transfusions of new elements and foreign turns of phrase, the larger, more forceful, and more flexible it becomes as an expressive medium. How sad to contemplate the efforts of know-nothing governments and exclusionary social movements to first invent and then foster the mythical 'purity' of a language by barring the use of any others within a national territory. The language they wish to preserve would eventually be worn away, eroded and impoverished by a lack of access to new and unfamiliar means of expression and communication, if it were not for irresistible, inevitable surges of enriching intercultural and mutilingual currents across the world.[35]

The same is true of the visual arts. Witness Marden's *Cold Mountain* paintings. Can one imagine depriving artists of access to any and every cultural resource that might inspire them?[36]

These few examples from just one encyclopedic museum remind us that works of art tell stories about both roots *and* routes, and have been doing so for a very long time. They are both witnesses to and arguments for not just the translation but the *relocation* of works of art. That is, as I have argued elsewhere, govern-

mental efforts to retain works of art within a given jurisdiction as evidence of a pure, essentialized, state-based identity are contrary to the truth and history of culture.[37] Efforts to proclaim a *national* culture are political acts meant to authorize a government's hold on power through the misuse of cultural precedent. All such efforts in the past have failed, and all today and in the future will as well. For culture has always circulated and engendered transculturation, which, as the art historian Finbarr Flood has used the term, "acknowledges that cultural formations are always already hybrid and in the process, so that a translation is a dynamic activity that takes place both *between* and *within* cultural codes, forms, and practices."[38]

: : :

The globalized world we live in might be different in pace, extent, and method of contact and exchange, but the fluidity of identities and attachments we associate with is not new. As Mohammed Bamyeh has said, "Globalization is a very old story yet to be remembered."[39]

Recently, with the pace of globalization quickening, new consideration has been given to the benefits and predicaments of a cosmopolitan view of the world. (As with the Enlightenment, there is currently what might be called a revival of interest in cosmopolitanism, which of course itself was revived by Kant in the 1780s and 1790s.)[40] In 1995, on the two-hundredth anniversary of Kant's treatise *Perpetual Peace*, the philosopher Martha Nussbaum published an essay tracing the origins and implications of Kant's cosmopolitanism from Diogenes the Cynic, who when asked where he came from replied, "I am a citizen of the world," to the Stoics and their idea of the *kosmopolitês* (world citizen), each of us dwelling in two communities—the local community of our birth and the greater community of human aspiration—the latter of which, quoting Seneca, is "truly great and truly common, in which we look neither to this corner nor to that, but measure the boundaries of our nation by the sun."[41] These and other sources, she argued, informed

Kant's defense of a politics based on reason rather than patriotism or group sentiment.

A year earlier, in 1994, Nussbaum had published an essay, "Patriotism and Cosmopolitanism," which was reprinted in book form in 2002 with responses from sixteen scholars and a reply by Nussbaum.[42] Once again Nussbaum turned to the Stoics, whom she credited with the view "that we should give our first allegiance to no mere form of government, no temporal power, but to the moral community made up by the humanity of all human beings." And like Kant, she argued that a cosmopolitan view encourages us to look at ourselves through the lens of the other so that "we come to see what in our practices is local and nonessential, what is more broadly or deeply shared."[43] For Nussbaum, patriotism interferes with and is the opposite of cosmopolitanism.

In his response, Kwame Anthony Appiah allowed for a cosmopolitan patriotism: "The cosmopolitan patriot can entertain the possibility of a world in which everyone is a rooted cosmopolitan, attached to a home of his or her own, with its own cultural particularities, but taking pleasure from the presence of the other, different, places that are home to other, different, people." "As cosmopolitans," he concluded, we should "defend the right of others to live in democratic states with rich possibilities of association within and across borders, states of which they can be patriotic citizens. As cosmopolitans, we claim that right for ourselves."[44]

The political scientist Richard Falk was disturbed by Nussbaum's "implicit encouragement of a polarized either/or view of the tension between national and cosmopolitan consciousness" and argued that, as currently formulated, neither patriotism nor cosmopolitanism offers a way out of the political circumstances of the late twentieth century (and if he were writing this today, he would include those of the early twenty-first century as well). At present, he argued, "the autonomy and primacy of the state," which he acknowledged to be the organizing basis of international society, "is being seriously and cumulatively compromised, if not challenged, and even superseded, by various types of regionalization and globalization, especially by complex forms of economic,

ideographic, and electronic integration." Moreover, "to project a visionary cosmopolitanism as an alternative to nationalist patriotism without addressing the subversive challenge of the market-driven globalism currently being promoted by transnational corporations and banks, as well as currency dealers and casino capitalists, is to risk indulging a contemporary form of fuzzy innocence." Falk argued for a reconfigured dichotomy between "undifferentiated patriotism" and cosmopolitanism that would restore patriotism "on the basis of extending ideas and practices of participation and accountability to transnational sites of struggle." On these terms, he saw the possibility of patriotism and cosmopolitanism sharing a common commitment to "refashioning conditions for the humane state, the humane region, and, depending on the success of transnational social forces, a decent, inclusive globalism."[45]

In his response, the sociologist Nathan Glazer argued that in the modern era, the process of change for the good in the world must be mediated "by the only institutions that have legitimacy and power, national states," that indeed "there is no other way to implement those aspects of cosmopolitanism that appeal to us."[46] Similarly, the literary scholar Elaine Scarry argued that the moral good of cosmopolitanism can only be sustained through constitutional means, the structures of government to which one is connected by nationalism: "Attempts to replace nationalism by internationalism often turn out to entail a rejection of constitutionalism in favor of unanchored good will that can be summarized under the heading of generous imaginings." "The work accomplished by a structure of laws," she concluded, "cannot be accomplished by a structure of sentiment. Constitutions are needed to uphold cosmopolitan values."[47]

Alan Wolfe shares this view. In *The Future of Liberalism*, he wrote:

We are not rootless individuals unattached to any particular community, liberals believe, but instead live in societies that continue to define themselves as nation-states with particular histories, policies, traditions, and rights. . . . Without a nation, neither liberty nor equality can be realized, for the former presupposes the existence of society and the latter

requires policies provided by the state. A citizen of the world must also be a citizen of a particular country. The difficult problem facing liberals is not whether to choose between national and global responsibilities but how to find ways to balance them.[48]

Wolfe contrasts romantic nationalism with constitutional patriotism: where the former essentializes the differences between one's own and every other country as natural and inalienable (as in Herder; see chapter 2), the constitutional patriot "loves her country in a cosmopolitan manner; she recognizes that it is one country among many, hopes to see it live up to the principles enshrined in its founding documents, and wishes it to adhere to international norms of justice and human rights."[49]

With one exception, these represent the range of recent responses to the promise of cosmopolitanism: it is opposed to the negative forms of nationalism; it allows for an ethical patriotism; it can't ignore the negative consequences of globalization; and without governmental force, both local and international, it remains only aspirational. The response not included is what some have called the "new cosmopolitanism."

Roxanne Euben has described the proliferating meanings of the "new cosmopolitanism" as perhaps "more meaningfully understood as signaling entry into a debate about the actual or desirable relationship between the local and global, rootedness and detachment, particularism and universalism, rather than denoting a consistent set of empirical or normative arguments."[50] She points out, for example, by quoting Sami Zubaida, that for many people, cosmopolitanism is "not the fact of multi-cultural coexistence, but the development of ways of living and thinking, style of life which are deracinated from communities and cultures or origin, from conventional living, from family and home-centeredness, and have developed into a culturally promiscuous life, drawing on diverse ideas, traditions, and innovations."[51]

In 2002 a group of South Asian scholars edited a collection of essays probing the current, changing circumstances of cosmopolitanism.[52] Their vision of today's cosmopolitanism stems not from

the virtues of rationality, universality, and progress, nor from the idealized figure of the "citizen of the world," but from the political and economic conditions of global capitalism: "Cosmopolitans today are often the victims of modernity, failed by capitalism's upward mobility, and bereft of those comforts and customs of national belonging. Refugees, peoples of the diaspora, and migrants and exiles represent the spirit of the cosmopolitical community."[53] They called for a "minoritarian modernity" as a source for contemporary cosmopolitical thinking. And they were critical of what they saw as the neoliberal framing of cosmopolitanism in terms of "disembodied, free-floating, or generalizing scientific or humanist thought." Instead of placing universal values at the center of cosmopolitan thinking (i.e., Kant's regard for human dignity and reason), they argued that "cosmopolitanism must give way to the plurality of modes and histories—not necessarily shared in degree or in concept regionally, nationally, or internationally—that comprise cosmopolitan practice and history."[54] And they insisted (and this is their real contribution) that any consideration of cosmopolitanism must include the particular histories and practices of non-European peoples, especially subaltern peoples who have been geographically, politically, and economically marginalized.

In his contribution, the Sanskrit scholar Sheldon Pollock contrasts the cosmopolitan forces of Latin and Sanskrit literary cultures and their relations to the vernacular. Both began their "spatial dissemination and expressive elaboration" a little before the beginning of the first millennium. Within four or five centuries, Sanskrit was in use for literary and political purposes from what is now Afghanistan to Java and from Sri Lanka to Nepal; Latin was similarly in use from Britannia to Mauretania (northern Africa) to Mesopotamia and Palestina. But Latin, Pollock claims, traveled as the language of a conquest state and a missionizing church, "obliterating" all literary cultures in its wake. By contrast, the Sanskrit cosmopolis was formed through the circulation of "traders, literati, religious professionals, and freelance adventurers," and "far from proscribing local script vernaculars, it mediated their creation everywhere it traveled and often at the very moment it arrived." In

the picture Pollock paints, "if the cosmopolitanisms were similar in transcending the local and stimulating feelings of living in a larger world, their modalities were radically different: the one coercive, the other voluntaristic."[55]

But that was in the past, Pollock admits, and things are different today. In contemporary India, "vernacularity [is] mobilized along the most fragile fault lines of region, religion, and caste and the grotesque mutation of the toxins of postcolonial ressentiment and modernity known as Hindutva, or fundamentalist Hinduism."[56] Here "universalism" occurs only within a narrow view of Hinduism and is precisely *not* a cosmopolitanism but a non–state-based, fundamentalist nationalism. The difficulty for Pollock is to find a way today to allow vernacularity within a cosmopolitanism as it existed within the Sanskrit world hundreds of years ago. Without suggesting how, he concludes that "the future must somehow become one of *and* rather than *either/or*.[57]

Mamadou Diouf struggles with the same problem: "how to elaborate a single explanation of both the process of globalization and the multiplicity of individual temporalities and local rationalities that are inserted into it." The answer he found is in the example of Murid traders, members of an Islamic brotherhood founded in Senegal in the nineteenth century. Since the end of colonial domination, they have traveled the world selling their wares and competing in the marketplace while maintaining their cultural traditions and a portable "local" identity within an expanding diaspora. In this respect, Diouf claims, "they are globalizing themselves." (Theoretically speaking, there is not much new here; diasporic peoples have long done this. The Hasidic community in Europe and North America is another example.) Diouf's argument is really not about cosmopolitanism, but globalization. Or rather, it is about finding a way to think of cosmopolitanism as a framework that would allow for local identities within global commercial networks: "Its modes of operation make its vernacular contribution to cosmopolitanism by exhibiting it at the heart of the procedures of globalization, thus promoting pluralization of cosmopolitan forms and of local variations of world time."[58] (Another contributor to

the volume, Walter Mignolo, put it this way: "Cosmopolitanism today has to become border thinking, critical and dialogical, from the perspective of those local histories that had to deal all along with global designs. Diversality should be the relentless practice of critical and dialogical cosmopolitanism rather than a blueprint of a future and ideal society projected from a single point of view [that of the abstract universal] that will return us [again!] to the Greek paradigm and European legacies."[59])

Cosmopolitanism is different than globalization. It is about negotiating identities and attachments within an increasingly dynamic world of commercial exchange and cultural contact, and in ways that allow for a plurality of such identities, made by choice, not determined by birth or state affiliation, and with a common regard for and stake in a shared history and promising future. We have already seen that the choice is not between cosmopolitanism and patriotism. The challenge is how to promote a respect for difference and the freedom to self-identify in a world of increasing nationalism and cultural, if not strictly religious, fundamentalism.

In 2004 the political philosopher Seyla Benhabib, delivering the Berkeley Tanner lectures, argued that since the UN Declaration of Human Rights in 1948, "we have entered a phase in the evolution of global civil society, which is characterized by a transition from *international* to *cosmopolitan* norms of justice." International norms of justice arise from treaty obligations and bilateral and multilateral agreements and regulate relations among states, whereas cosmopolitan norms of justice "accrue to individuals as moral and legal persons in a worldwide civil society." Both bind and bend the will of sovereign nations. And yet, as with other forms of cosmopolitanism, "the relationship between the spread of cosmopolitan norms and democratic self-determination is fraught, both theoretically and politically." For "modern democracies act in the name of universal principles, which are then circumscribed within a particular civic community."[60]

As examples, Benhabib explored the French *affaire du foulard*— the debate over whether Muslim girls would be allowed to wear head scarves in public schools (as noted in chapter two and argued

on the basis of *laïcité*, or the constitutional neutrality of the state toward religious practices)—and the recent debate over German voting laws, who can and cannot become a German citizen, and the rightful extent of the power of the democratic sovereign to make and remake such decisions. Benhabib's answer to the question of how to reconcile cosmopolitanism with the legal, historical, and cultural traditions and memories of a people and the sovereignty of the state is "to initiate multiple processes of democratic iteration" and appeal to multiple constitutional authorities within the state and, beyond the state, to bodies of international jurisprudence. Each of these, of course, is ultimately subject to the authority of the state, but the rise of cosmopolitan norms of justice "increases the threshold of justification to which formerly exclusionary practices are now submitted. . . . It becomes increasingly more difficult to justify practices of exclusion by democratic legislatures simply because they express the will of the people; such decisions are now subject not only to constitutional checks and balances in domestic law but in the international arena as well."[61]

: : :

What does this mean for encyclopedic museums? As cosmopolitan institutions, presenting representative examples of the world's artistic legacy, they promote tolerance and understanding of difference; encourage identification with others, a shared sense of history, and the recognition that a common future is at stake; and stand as evidence against the political proposition that cultures can be essentialized and "national," fixed manifestations that pit one state-based identity—one people—against another in a "clash of civilizations." As Roxanne Euben has written:

> Words have power, and whether the opposition is between "the West and the Rest" or the "West and Islam," the presupposition of two uniform and identifiable entities whose boundaries are clearly demarcated from one another carves up the world in ways that erase fissures within each

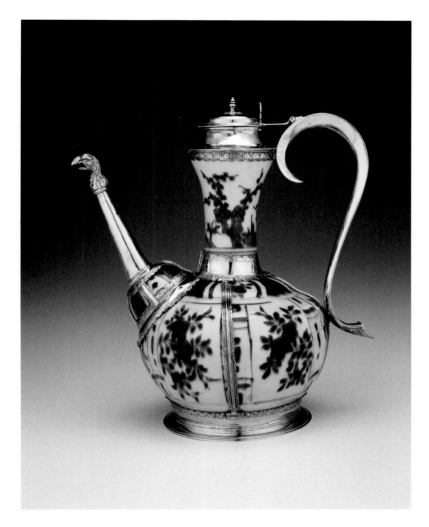

PLATE 1. Ewer, silver mounts: English, ca. 1610; hard-paste porcelain with underglaze decoration: Chinese, Ming dynasty, Wanli period, 1573–1620. Gift of Mr. and Mrs. Medard W. Welch, 1966.133, The Art Institute of Chicago. Photograph © The Art Institute of Chicago.

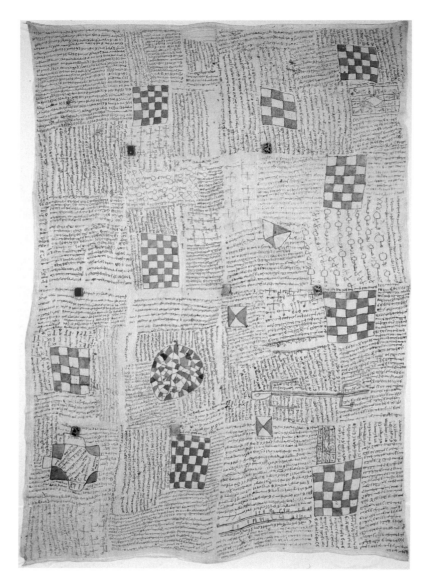

PLATE 2. Talismanic textile, probably Senegal, late nineteenth century, cotton plain weave, painted, amulets of animal hide and felt attached by knotted strips of leather. African and Amerindian Purchase Endowment, 2000.326, The Art Institute of Chicago. Photograph © The Art Institute of Chicago.

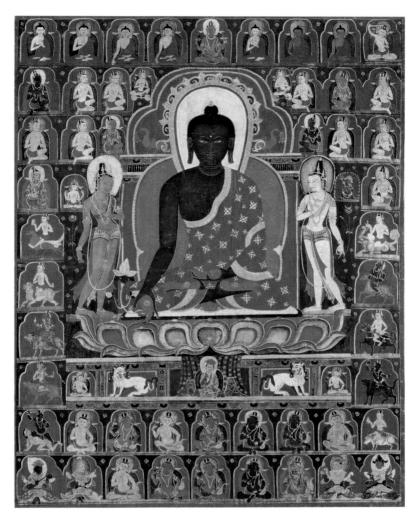

PLATE 3. *Thangka with Bhaishajyaguru, the Medicine Buddha*, Tibet, thirteenth/ fourteenth century, pigment and gold on cotton. Kate S. Buckingham Fund, 1996.29, The Art Institute of Chicago. Photograph © The Art Institute of Chicago.

PLATE 4. Brice Marden, *Cold Mountain 2*, 1989–1991, oil on linen. Hirshhorn Museum and Sculpture Garden, Washington, DC, Holenia Purchase Fund, in memory of Joseph H. Hirshhorn, 1992. © Brice Marden/Artists Rights Society, New York. Courtesy Matthew Marks Gallery, New York.

category and the mutual historical indebtedness between them, not to mention the extensive cross-pollination of the present.[62]

Encyclopedic museums bear witness to the truth that culture is hybrid and mongrelized, evidence to the intertwined history of cultures and the connectedness that has always marked our globalized history. For some scholars, hybridity, like cosmopolitanism, is controversial. Sheldon Pollock has called it, and "its usual connotations mélange or mongrelization, a banal concept and a dangerous one, implying an amalgamation of unalloyed, pure forms, whether vernacular or cosmopolitan, that have never existed."[63] Yet we have already noted that, as one translation theorist has described it, the mongrelization of languages (and I have argued that the same is true of visual forms) occurs because their "interiors" and "exteriors" are separated by porous, elastic membranes and not rigid walls, yet each language retains its identity in relation to other languages. That is—as we have seen at work in the reproduced examples of blue and white ware and in Marden's *Cold Mountain* paintings, prints, and drawings—hybridity does not presume the prior existence of *pure* forms precisely because there are none (all forms are hybrid), and it doesn't eliminate the generative source but includes it, transformed, in the resulting new work. Hybridity bears witness to contact and translation, such that each form retains its distinction while being changed and enhanced in the process.

Hybridity is more a process than a state. It is always active and inevitable because culture has never known political boundaries. Not even the military might of imperialism and colonialism has protected one culture from another, as the postcolonial cultural critic Homi Bhabha has written:

> Hybridity is the revaluation of the assumption of colonial identity through the repetition of discriminatory identity effects. It unsettles the mimetic or narcissistic demands of colonial power but reimplicates its identifications in strategies of subversion that turn the gaze of the discriminated

back upon the eye of power. For the colonial hybrid is the articulation of the ambivalent space where the rite of power is enacted on the site of desire, making its objects at once disciplinary and disseminatory - or, in my mixed metaphor, a negative transparency."[64]

: : :

I end this chapter by suggesting that encyclopedic museums are iterative institutions, in the sense expressed by Benhabib:

> In the process of repeating a term or concept, we never simply produce a replica of the original usage and its intended meaning: rather, every repetition is a form of variation. Every iteration transforms meaning and adds to and enriches it. In fact, there really is no "originary" source of meaning, or an "original" to which all subsequent forms must conform.... Every iteration involves making sense of an authoritative original in a new and different context.[65]

And conversely:

> when the creative appropriation of that authoritative original ceases or stops making sense, then the original loses its authority on us as well. Iteration is the reappropriation of the "original"; it is at the same time its dissolution as the original and its preservation through its continuous deployment.[66]

In their collections, which comprise discrete iterations (hybrid works of art), encyclopedic museums present examples of the iterative process at work—appropriation, reappropriation, dissolution, and preservation through deployment—and engage our critical faculties in the exploration of it. Then, as public institutions, they encourage "democratic iterations," which "not only change established understandings but also transform what passes as the valid or established view of an authoritative precedent." In other words, as I have been arguing, encyclopedic museums, as Enlightenment institutions, hold as their working premise Condorcet's statement

that "we must have the courage to examine everything" and Kant's conclusion that "our age is the age of criticism, to which everything must be subjected."[67]

In the province of legal theory (Benhabib's disciplinary domain) democratic iterations suggest that "a democratic people, which considers itself bound by certain guiding norms and principles, engages in iterative acts by reappropriating and reinterpreting these, thereby showing itself to be not only the *subject* but also the *author of the laws*."[68] In the case of encyclopedic museums, this means that not only the artists of the works in their collections produced an iteration of a previous work (or a more general cultural influence) but that each visitor who confronts a work of art and gives herself a narrative account of it is both subject and author of her experience, exercising her authority against any effort by the political elite to claim a cultural tradition for its own and impose a fixed meaning on the visitor. In the contest between a cosmopolitan or more local view of the world, the encyclopedic museum accomplishes something that Benhabib attributes to cosmopolitanism itself: it "increases the threshold of justification to which formerly exclusionary practices are now submitted."

This is the powerful importance of encyclopedic museums. They are archives of individual iterations that enrich the meanings of works of art, embolden the visitor, and complicate our tendency to reduce their aesthetic qualities to essentialized cultural, even national, attachments. As Homi Bhabha has written:

> Cultures come to be represented by virtue of the processes of iteration and translation through which their meanings are very vicariously addressed to—through—an Other. This erases any essentialist claims for the inherent authenticity or purity of cultures which, when inscribed in the naturalistic sign of symbolic consciousness frequently become political arguments for the hierarchy and ascendance of powerful cultures.[69]

This I take to be evident in encyclopedic museums and the argument for their enhancement and propagation.

The Imperial Museum

A national culture that does not have the confidence to declare that, like all other national cultures, it too is a hybrid, a crossroads, a mixture of elements derived from chance encounters and unforeseen consequences, can only take the path to xenophobia and cultural paranoia.

SANJAY SUBRAHMANYAM[1]

Despite efforts in words and wars to put national unity at the center of the political imagination, imperial politics, imperial practices, and imperial cultures have shaped the world we live in.

JANE BURBANK AND FREDERICK COOPER[2]

Whenever I argue the promise of encyclopedic museums in public forums, inevitably I am confronted with the charge that such museums are the result of empire, manifestations of historical imbalances of power by which stronger nations enriched themselves at the expense of weaker ones. I always reply that while they might be witnesses to empire—not only in the years since their founding but, with their deep historical collections, ever since imperialism has existed in the world—they are not *instruments* of empire. The legacy of empire—whether political, economic, or cultural, and always entwined with colonialism and nationalism—is complex and needs to be considered carefully.

Much of the best writing on the intersection of empire and nationalism has been by historians, literary critics, and social scientists in India (or in the Indian diaspora) engaged in analyzing

and theorizing the postcolonial condition. Among the most pro-
lific is Partha Chatterjee, a founder of the Subaltern Studies Collec-
tive, a group of scholars that first came together in the 1980s to give
voice to the unrepresented in histories of Indian nationalism and
to counter what they saw as colonialist and bourgeois-nationalist,
elitist interpretations of that history:

> What is clearly left out of this unhistorical historiography is the *politics*
> *of the people.* For parallel to the domain of elite politics there existed
> throughout the colonial period another domain of Indian politics in which
> the principal actors were not the dominant groups of the indigenous
> society or the colonial authorities but the subaltern classes and groups
> constituting the mass of the laboring population and intermediate strata
> in town and country—that is the people.[3]

The collective, as a later member, Dipesh Chakrabarty, put it, is
"opposed to nationalist histories that portrayed nationalist leaders
as ushering India and its people out of some kind of precapitalist
stage into a world-historical phase of 'bourgeois modernity,' prop-
erly fitted out with the artifacts of democracy: the rights of citizen-
ship, a market economy, freedom of the press, and the rule of law."[4]
We should be clear from the start (and it should be no surprise) that
the history of Indian nationalism is a contested field, whether in
practice or in its scholarly writing up.

In an essay published in 1991, Chatterjee answered Benedict
Anderson's influential formulation of nations as "imagined com-
munities" with the question "Whose imagined community?"[5]
His point was that not all nationalisms are alike and Anderson's
claim that Western examples have provided models for nationalist
elites in Asia and Africa is false. Precisely the opposite is true, he
argues: "The most powerful as well as the most creative results of
the nationalist imagination in Asia and Africa are posited not on an
identity but rather on a *difference* with the 'modular' forms of the
national society propagated by the modern West."

Like Chakrabarty (see chapter 1), Chatterjee locates India's *differ-*
ence in its rooted attachment to the spiritual and irrational. In an

analysis of nationalist thought in the colonial world, he charted the development of Indian nationalism and noted the contributions of both the rational (instruments of industry and government) and the irrational (the passion and moral will of the masses).[6]

The first stage was advanced by Bankimchandra Chattopadhyay, who called for uniting European industries with Indian *dharma*: "The industries and sciences of the West can be learnt and emulated while retaining the spiritual greatness of Eastern culture."[7] That greatness was to be institutionalized through a system of education, enhanced by a new national religion based on a Hindu ideal.[8] The latter held the promise of broad participation by the people in a movement that would nevertheless be led by the educated elite.

The second stage was marked by Gandhi's strategy of mobilizing the masses in "an attack on every constituent aspect of modern bourgeois society."[9] "As long as Indians continue to harbour illusions about the 'progressive' qualities of modern civilization, they will remain a subject nation. . . . It is not the physical presence of the English which makes India a subject nation: it is civilization which subjects."[10] *Khādī* (spinning of cotton as a means or rural self-employment and self-reliance), combined with the *Swadeshi* movement (a boycott of foreign-made goods) and *satyāgraha* ("peasant-communal resistance to oppressive state authority"), provided the ideological basis for including the whole people within the political nation, if not the state.

Nehru was left in the final stage to reconstitute the nationalist discourse into a legitimate state ideology and to establish a sovereign nation-state (to forge, as one scholar put it, the bourgeois compact between Gandhian nonviolence and Nehruvian socialism[11]): "If the political objective was not kept firmly in mind, all attempts at social reform would flounder, energies would be wasted, and the movement would play into the hands of the foreign government now holding power."[12] The state, as Nehru envisioned it, would stand above narrow interests and scientifically plan and direct economic processes to ensure progress, justice, and the "full and equal rights of citizenship, irrespective of religious, linguistic

or other cultural differences."[13] This required that India "function in line with the highest ideals of the age we live in: humanism and the scientific spirit."[14]

Humanism and the scientific spirit. In Chatterjee's words:

> The two domains of politics—one, a politics of the elite, and the other, a politics of the subaltern classes—[were] replicated in the sphere of mature nationalist thought by an explicit recognition of the split between a domain of rationality and a domain of unreason, a domain of science and a domain of faith, a domain of organization and a domain of spontaneity.[15]

Members of the Subaltern Studies Collective argued that there was no unitary Indian state and that the coexistence of the two domains was the index of an important historical truth: "the failure of the Indian bourgeoisie to speak for the nation."[16] And that failure had immediate political consequences. Within six months of independence, Gandhi was killed by a Hindu nationalist with ties to the right-wing nationalist party Rashtriya Swayamsevak Sangh (RSS). The stated charge was that too many concessions had been made to Muslim "separatists" at the moment of partition. The moral leader of the subalterns fell victim to sectarian violence.

Much of the tension between the nation and the state in India, and between its "two domains of politics," has centered on Hindu-Muslim relations and the religious constituencies' competing claims on national identity. (In his famous lecture on "Nationalism in India," delivered some three decades before independence, Rabindranath Tagore put it simply: "From the earliest beginnings of history India has had her own problem constantly before her—it is the race problem."[17]) Most recently, this tension has been fueled by actions and claims of the Hindu right and its ideology of *hindutva*, or Hinduness.[18]

The Bharatiya Janata Party (BJP, founded in 1980 with links to the RSS) holds that "the past, present, and future of the Indian nation [must] be constituted around a notion of *hindutva*."[19] During the 1980s, encouraged by the BJP, Hindu organizations began ral-

lying at the site of the Babri Mosque in Uttar Pradesh, a populous state in northern India, bordering Nepal. The mosque was one of India's largest (there are more than 140 million Muslims in India) and believed by the Hindu right to have been constructed on the site of the birthplace of Rama. (They hold that a Hindu temple built in Rama's name was destroyed when the mosque was built in 1528.) In 1989 a judicial procedure allowed Muslims continued access to the mosque against the pleas of the Hindu right. In the same year, historians at the Center for Historical Studies at Jawaharlal Nehru University published a pamphlet titled "The Political Abuse of History: Babri-Masjid-Rama-Janma-Bhumi Dispute," making the case that the Hindu right's claim that a Rama temple lay beneath the mosque was based on myth rather than history.[20] Then in 1992, the BJP rallied some two hundred thousand people at the mosque and, although the Indian supreme court had been assured that the mosque would not be harmed, the surging crowd broke through the cordon and destroyed the structure with sledgehammers, yelling, "Death to the Muslims." A few months later, Hindu-Muslim rioting broke out in Mumbai, killing more than five hundred people and driving forty thousand more from the city. Over the next four years, BJP representation in parliament increased rapidly; it took power in 1998 and held it until 2004.

As William Dalrymple recounts, the BJP moved quickly to take on India's academic historical establishment, replacing academics in public positions with political appointees, nonhistorians from the ultranationalist far right.[21] New national history textbooks were published and "any suggestion that medieval Indian civilization might have developed its extraordinary richness specifically because of its multiethnic, multireligious character was suppressed." Emphasis was placed on historical atrocities by Muslims against Hindus, to which academic historians responded with outrage, documenting errors of fact and pointing out the inherent essentialism in the right's characterization of "Muslim" and "Hindu."

In March 2002 Hindu hardliners threatened to conduct a prayer session at the site of the destroyed Babri Mosque. The BJP-led government in New Delhi allowed them to carry two carved sandstone

pillars through town on a bright orange rickshaw, symbols of their intention to build a Rama temple on the site. A government representative joined the group in prayer service and accepted the consecrated pillars, prompting the Vishva Hindu Parishad (World Hindu Council) to rally in recognition of the government's support.[22] A month later widespread violence broke out in the western state of Gujarat. A Muslim mob attacked a train, killing fifty-nine people. Hindus retaliated and Muslims responded. More than a thousand people were killed in Ahmedabad alone. Many of their bodies were set alight by their killers.[23]

Throughout the 1990s, the economist and philosopher Amartya Sen wrote searchingly about the political and cultural disputes in India. In one essay he argued that the claim of a Hindu identity for India and Indians fails to recognize the implications of India's "immense religious diversity" and the religious plurality within Hinduism itself.[24] "The cultural inheritance of contemporary India," he wrote, "combines Islamic influences with Hindu and other traditions, and the results of the interaction between members of different religious communities can be seen plentifully in literature, music, painting, architecture and many other fields," including Hindu beliefs and practices themselves.[25]

Sen points to the Mughal emperor Akbar as evidence of the long history in India of pluralism and reasoned, public disputation. Already in the sixteenth century, Akbar laid "the foundations of the secularism and religious neutrality of the state which he insisted must ensure that 'no man should be interfered with on account of religion, and anyone is to be allowed to go over to a religion that pleases him.'" He abolished discretionary taxes on non-Muslims, trusted his armies to a Hindu general, invited intellectuals and artists of all faiths to discuss and debate the merits of their beliefs, and deployed reasoned inquiry in defense of a tolerant multiculturism: "The pursuit of reason and rejection of traditionalism are so brilliantly patent as to be above the need of argument. If traditionalism were proper, the prophets would merely have followed their own elders and not come with new messages," Akbar remarked to his friend Abul Fazl, the Sanskrit, Arabic, and Persian scholar.[26] Even

when deciding on one's faith, he held that one should be led by "the path of reason" (*rahi aql*) rather than "blind faith."

For Sen, this contradicts the view held by some Western intellectuals that the West has "exclusive access to the values that lie at the foundation of rationality and reasoning, science and evidence, liberty and tolerance, and of course rights and justice."[27] And it challenges the claim by some Indian scholars that a regard for reason is an import to India from Enlightenment Europe and an instrument of imperial power.[28] "The nature and strength of the dialogic tradition in India," he argues, "is sometimes ignored because of the much championed belief that India is the land of religions, the country of uncritical faiths and unquestioned practices." And while this may be inspired by sympathy, "it can end up by suppressing large parts of India's intellectual heritage."[29]

As an economist, Sen is interested in the use of reason in matters of public policy (with regard to famine, poverty, and markets, for example). As a philosopher, he is interested in how it can be used to address the question of individual agency and personal and cultural identity.[30] Why, he asks, should people be "inescapably confined to their traditional modes of thought" when they have the power of reason and can use it to critique received opinion and dogma? Why too, as some claim, can people only *detect* or discover their identity rather than *determine* it through reasoned inquiry? As humans we have multiple affiliations—gender, class, religion, nation, and so on—and needn't choose only one as defining of our identity. He recounts the time during the communal riots in 1944 when a bleeding Muslim man rushed into his family's garden in Dhaka (then India, now Bangladesh), having been attacked by rioting Hindus. The man and his attackers shared an economic identity—they were poor laborers—but no identity other than religious ethnicity was allowed to count for them. Identity can be a source of richness and warmth, he acknowledges, "but it can also kill and kill with abandon."[31]

Sen shares these concerns with Rabindranath Tagore, the earlier writer, educator, and artist and India's first Nobel Prize winner (Sen, of course, would become another). A fierce opponent of im-

perialism and a proponent of national self-determination, Tagore was also a critic of the rigid and aggressive kind of nationalism that blunts moral conscience and denies individual agency in the determination of personal and cultural identities. In his lecture "Nationalism in India," first published in 1917, Tagore confessed that he had outgrown the teaching of his childhood, which held "idolatry of the Nation [to be] almost better than reverence for God and humanity," and was now convinced that "my countrymen will truly gain their India by fighting against the education which teaches them that a country is greater than the ideals of humanity."

It was the freedom to reason in pursuit of moral right and political independence that Tagore valued most. And he opposed any kind of cultural separatism. "The objective of Indian history," he wrote, "is not to set up Hindu or some other dominance, but to secure a special kind of fulfillment for humanity, a level of perfection that must be a gain for all."[32] After all, the world's cultural achievements belong to everyone: "Whatever we understand and enjoy in human products instantly becomes ours, wherever they might have their origin. I am proud of my humanity when I can acknowledge the poets and artists of other countries as my own. Let me feel with unalloyed gladness that all the great glories of man are mine."[33] This was the basis of Tagore's educational philosophy, and he held education to be the key to India's independent future.

Concerned that there be wider opportunities for education across the country, especially in the rural areas, and that it should be lively and inspire, he founded a progressive, coeducational school in the small Bengali town of Santiniketan in 1901 (where Sen would later be a student). There he pioneered a curriculum and practice that focused on empowering the individual student through Socratic argument, exposure to diverse world cultures, engagement with the arts, and consideration of world citizenship. In 1922 he established the Institute of Rural Reconstruction, which with his school became Visva-Bharati, an international university with the Vedic motto *Yatra visvam bhavate eka nidam* (Where the world meets in a nest).[34] An early prospectus for the university emphasized its cosmopolitan mission:

College students are expected to become familiar with the working of existing institutions and new movements inaugurated in the different countries of the world for the amelioration of the social condition of the masses. They are also required to undertake a study of international organizations so that their outlook may become better adjusted to the needs of peace.[35]

Such was the basis of Tagore's understanding of—*and his argument with*—nationalism. In the end, he declared, "there is only one history—the history of man. All national histories are merely chapters in the larger one."[36]

: : :

A recent report of UNESCO's World Commission on Culture and Development concluded that "no culture is a hermetically sealed entity. All cultures are influenced by and in turn influence other cultures. Nor is any culture changeless, invariant, or static. All cultures are in a state of constant flux, driven by both internal and external forces."[37] These circumstances—and the fact that over the last two or three decades we have seen more people than ever before moving across or within national borders (some forty million foreign workers, twenty million refugees, and twenty to twenty-five million internally displaced persons)—have strained the nation-state and changed the way we think of nations: no longer as politically defined and territorially circumscribed, but as discursive fields of cultural signification or "imagined communities" (in Homi Bhabha's formulation, *nation as narration*).[38] This has led Arjun Appadurai to argue that the principles and procedures of the modern nation-state—"the idea of a sovereign and stable territory, the idea of a containable and countable population, the idea of a reliable census, and the idea of stable and transparent categories"—have come so unglued in our era of globalization that they have produced "new incentives for cultural purification as more nations lose the illusion of national economic sovereignty or well being." The result, he claims, is a dangerous, often violent "narcissism of minor differences."[39]

Edward Said, whose influence on postcolonial studies was profound, dedicated his professional life to examining and critiquing the formation of national cultural identities on just these terms. The basis of his critical practice was that "no institution or epistemology . . . can or has ever stood free of the various sociocultural, historical, and political formations that give epochs their peculiar individuality."[40] He refused to accept "the supremely stubborn thesis that everyone is principally and irreducibly a member of some race or category, and that race or category cannot ever be assimilated to or accepted by others—except as itself."[41] In a 1998 essay in the *London Review of Books*, he was blunt:

> Identity as such is about as boring a subject as one can imagine. Nothing seems less interesting than the narcissistic self-study that today passes in many places for identity politics, or ethnic studies, or affirmations of roots, cultural pride, drum-beating nationalism, and so on.[42]

He was devastatingly critical of Samuel Huntington's "clash of civilizations" thesis, arguing that it showed the author "interested more in policy prescription than either history or the careful analysis of cultural formations." Said insisted that the real question is "whether in the end we want to work for civilizations that are separate or whether we should be taking the more integrative, but perhaps more difficult, path, which is to try to see them as making one vast whole whose exact contours are impossible for one person to grasp, but whose certain existence we can intuit and feel."[43]

Said was a professor of comparative literature at Columbia University and wrote critically of the academy. In a lecture delivered in South Africa and published in 1991, he surveyed conditions in universities in the United States and the Arab lands. Of the latter, he wrote that upon independence they had understandably moved to reclaim educational territory that had long been dominated by Ottoman and European colonial powers. But soon enough, during the cold war and the Arab-Israeli struggle (today he would include the US "war on terrorism"), they became extensions of

the then-emerging national security state, crucibles for shaping national identity: "Alas, political conformity rather than intellectual excellence was often made to serve as a criterion for promotion and appointment, with the general result that timidity, a studious lack of imagination, and careful conservatism came to rule intellectual practice."[44] US universities, while far less governmentally controlled (faculty are rarely civil servants), were still subject to debates over the cultural and national identity of the education being offered (for and against the supremacy of the Western canon). In both cases, Said raised the question "of how the central importance and authority given the national identity impinges on and greatly influences, surreptitiously and often unquestioningly, academic freedom—that is, what transpires in the name of academic freedom."

Said's point was clear: all cultures teach about themselves; that's understandable, but because no culture exists in isolation, we must also look at what other cultures, other traditions, other national communities contribute as we study our own. The questions for the nations newly liberated from colonialism are "what intellectually and academically do we do with our earned liberation . . . what kind of authority, what sort of human norms, what kind of identity do we then allow to lead us, to guide our study, to dictate our educational processes?" Nationalism, he argued, is a necessary thing, but it is only the first step:

> To presume that the ends of education are best advanced by focusing principally on *our own* separateness, our own ethnic identity, culture, and traditions, ironically places us where as subaltern, inferior, lesser races we had been placed by nineteenth-century racial theory, unable to share in the general riches of human culture.

The world is made up of numerous interacting identities, not to deal with that whole, Said concluded, is to lack academic freedom. Our model for academic freedom should be the migrant or the traveler:

The image of the traveler depends not on power but on motion, on a willingness to go into different worlds, use different idioms, and understand a variety of disguises, masks, and rhetorics. Travelers must suspend the claim of customary routine in order to live in new rhythms and rituals. Most of all, and most unlike the potentate who must guard only one place and defend its frontiers, the traveler *crosses over*, traverses territory, and abandons fixed positions, all the time.[45]

Said emphasized the purpose and ambition of the study of comparative literature. It is, he wrote, "to move beyond insularity and provincialism and to see cultures and literatures together, contrapuntally."

There is an already considerable investment in precisely this kind of antidote to reductive nationalism and uncritical dogma: after all, the constitution and early aims of comparative literature were to get a perspective beyond one's own nation, to see some sort of whole instead of the defensive little patch offered by one's own culture, literature, and history.[46]

Ironically, however, the study of comparative literature "originated in the period of high European imperialism and is irrecusably linked to it." Said then went on to trace the history of comparative literature and concluded by stating:

If I have insisted on integration and connections between the past and the present, between imperializer and imperialized, between culture and imperialism, I have done so not to level or reduce differences, but rather to convey a more urgent sense of the interdependence between things.[47]

Said wrote of—and imaginatively *from within*—the consequences of empire. And he insisted that any consideration of them not reduce imperialism to a one-dimensional straw man:

So vast and yet so detailed is imperialism as an experience with crucial cultural dimensions, that we must speak of overlapping territories, intertwined histories common to men and women, whites and non-whites,

dwellers in the metropolis and on the peripheries, past as well as future; these territories and histories can only be seen from the perspective of the whole of secular human history."[48]

Empire is a durable and varied form of state. The Ottoman Empire lasted six hundred years, successive Chinese empires two thousand years, and the Roman Empire four hundred years from its metropolitan center in the western Mediterranean and another thousand years as its eastern offshoot, the Byzantine Empire. Egyptians lived in empires for nearly three thousand years, and empires came and went in Mesopotamia, India, Africa, and Asia for hundreds of years before the Romans and Chinese. The Romans built much of their early imperial foundation on the remnants of the Greek empire, and the Chinese built theirs on earlier empires in northern and central China, dating back to at least 1750 BC.

Each empire approached the questions of political belonging and how to treat people from outside its core culture differently. Rome, for example, "promoted the notion of a singular superior political community based on shared rights and culture," whereas China "accommodated and exploited inputs from outsiders, and the empire's diplomacy paid heed to the reality of alien powers and the respect due to them."[49] Chinggis Khan and his successors ruled over the largest land-based empire in history through shifting alliances, pragmatic politics, exogamous marriages, and religious pluralism. (Chinggis's son married a Nestorian Christian woman, whose son, Khubilai, became a Buddhist and emperor of China. Il-Khan Oljeitu was probably a Shamanist, a Buddhist, a Christian, and a Sunni and Shiite Muslim at different times in his life.) And we have already seen how inclusive and strategic Akbar was as a Mughal emperor. It wasn't until the rise of race-based theories of nationalism in the nineteenth century that the two modes of classifying people—nation and race—became more salient and more clearly defining of who was in the polity and who was not.

Empire's history is long and its reach extensive. By the start of the Second World War, 42 percent of the world's land area and 32 percent of its population was colonized by the United States,

Japan, and Western Europe alone.[50] Then two large empires were defeated and broken up. India and colonies throughout Africa and Southeast Asia gained independence. And the Soviet Union collapsed. Yet empire and other forms of extranational economic and political influence persist. China has returned to, if not empire, at least a position of worldwide influence, exercising ever more forceful military control over an extent of territory as large as that of its last empire, the Qing. And the United States continues to deploy a range of imperial strategies: occupying countries, dispatching troops to remove hostile leaders, sponsoring proxy wars, making use of military bases on foreign soil, and supplying development aid and expertise, all in the service of national self-interest.[51] The rise—and instability—of the nation-state has not eliminated the presence and contest of imperial powers. And neither the nation-state nor the imperium has fully come to grips with the mixing of people across space or the challenge of building better polities. The legacy of empire remains with us still. And throughout, as in empire itself, social difference does not everywhere imply a simple binary split into colonized and colonizer.

This is the context in which the encyclopedic museum was founded and has thrived and with which it is irrecusably linked. It isn't enough to say that the encyclopedic museum is the result of empire, even if over the course of its history its fate has been intertwined with the imbalances of power that allow for, and come with, empire. Its diverse collections stand as evidence of the fact that, as Said has written, "partly because of empire, all cultures are involved in one another; none is single and pure, all are hybrid, heterogenous, extraordinarily differentiated, and unmonolithic."[52] Such mixing, it must be noted, is the result of empire since the beginning of time and not just since the advent of modern European imperialism.

The blue and white ewer (plate 1) is evidence of empire, surely: the Ming Empire within which it was made, the Safavid dynasty of the Iranian Empire through which it likely passed, and the imperial reaches of the East India Company, which no doubt explains its presence in Jacobean England. But so is the Benin plaque (fig. 5), bearing the imprints both of the historical Benin Empire and of

European empires, the Portuguese and the British. And the Ghandaran bodhisattva (fig. 7), witness to empire from Cyrus's Persia to that of Alexander the Great and the subsequent Mauryan, Kushan, and Sasanid empires. Should one look for evidence of empire, whether of a political, economic, or cultural kind, one can find it everywhere in the encyclopedic museum, for it is a fact of history, and history is objectified in the museum's collections. The question is, what does one do with this?

Said asked this question of his academic discipline, comparative literature, and noted the contributions of early "comparativists"— Ernst Curtius and Eric Auerbach—for whom nationalism was transitory: "What mattered far more was the concert of peoples and spirits that transcended the shabby political realm of bureaucracy, armies, custom barriers, and xenophobia." From this "came the idea that the comparative study of literature could furnish a transnational, even trans-human perspective on literary performance." But in its early years "the field was epistemologically organized as a sort of hierarchy, with Europe and its Latin Christian literatures as its center and top."[53] Said's answer to this is not to condemn or dismiss his discipline and its early contributors but to argue for its further development. That was his intellectual project: to look at the intertwined histories of cultures in the context of the gritty and granular truth of local politics (of nationalism and imperialism), what he called *articulation* and *activation*,

> which can only come about if we take serious account of the present, and notably of the dismantling of the classical empires and the new independence of dozens of formerly colonized peoples and territories.... Then we can grasp in a new and more dynamic way both the idealist historicism which fuelled the comparatist "world literature" scheme and the concretely imperial world map of the same moment.[54]

In another formulation, he wrote that the history of culture is not univocal but contrapuntal, "with a simultaneous awareness both of the metropolitan history that is narrated and of those other histories against which (and together with which) the dominating dis-

course acts." His reference was to Western classical music, about which he wrote with considerable sophistication, "in which various themes play off one another, with only a provisional privilege being given to any particular one; yet in the resulting polyphony there is concert and order, an organized interplay that derives from the themes, not from a rigorous melodic or formal principle outside the work."[55] He could equally have referenced improvisational musical traditions, which employ call and response and variation. The point was that culture—and cultural forms—are never pure and fixed but always mixed and dynamic, and any account of them must admit this (what he called "the contestatory force of an interpretative method").

The difference between comparative literature and encyclopedic museums, of course, is that the former is an interpretative method and the latter an archive. I have argued that museums are sites of reasoned disputation and interpretation. They don't prescribe a particular interpretative methodology but allow for individual choice: they acknowledge and respect the individual agency of their visitors. What's important is that they exist to preserve and present their collections for the public in a secular manner. That is, they argue against any one claim for a work of art's having been culturally determined by a race, nation, or religion, and they present works of art from different cultures without prejudice or privilege. I have already criticized the claims by Carol Duncan and Alan Wallach on the museum as an agent of the state and the experience of the museum as ritualistic, resembling a religious experience (chapter 2). I return to those claims here, briefly, because they are deployed in an interesting reading with regard to the destruction of the Bamiyan Buddhas in Afghanistan and the role of the encyclopedic museum.

In an article on the question of iconoclasm in Islamic art, the art historian Finbarr Flood repeats a notion presented by Duncan, that "as its etymology (and often its architecture) implies, the museum is a type of secular temple, a 'temple of resonance,' within which modernity is equated with the desacralization and even 'silencing'

of inanimate objects by their transmutation into museological arti-facts."[56] He then cites Alfred Gell:

> I cannot tell between religious and aesthetic exaltation: art-lovers, it seems to me, actually do worship images in most of the relevant senses, and explain away their de facto idolatry by rationalizing it as aesthetic awe. Thus to write about art at all is, in fact, to write about either religion, or the substitute for religion which those who have abandoned the outward forms of received religions content themselves with."

As Gell observes, "We have neutralized our idols by reclassifying them as art; but we perform obeisances before them every bit as deep as those of the most committed idolator before his wooden god."[57]

Flood evokes these and other authors in the context of arguing that to collect works of art that were made for religious purposes and bring them into the museum is in effect to desacralize them, to commit a kind of "iconoclasm." But it can't be that the museum both desacralizes former cult objects, silences and neutralizes them, *and* brings them into a new, pseudoreligious context where obeisances are performed just like those of an "idolator before his wooden god." It must be rather that the museum "converts" an object from one cult status to another, and from one cult to an-other. If there is controversy here, it is not about desacralization or iconoclasm but about conversion, about changing the specific "religious" context within which an abject takes on meaning. In the light of postcolonial politics, this is a controversy over who has authority over that meaning: those who identify with the culture within which the object had its initial meaning or those who, by bringing it into a museum's collection, give it new meaning.

Take the case of the Bamiyan Buddhas, the example Flood him-self deploys. Long treasured by Buddhist pilgrims and Western scholars, the Buddhas attracted a different kind of attention with the rise of the Taliban to power in Afghanistan in the mid-1990s. What role could the colossal sculptures now play in a strictly con-servative Islamic society that opposed the worship of idols? In 1999

the Taliban leader Mullah Muhammad Omar issued a decree call-
ing for their preservation. Since there were no more Buddhists in
Afghanistan, he said, they could not be worshipped and thus held
no idolatrous power. But then two years later, he reversed his posi-
tion. On February 26, 2001, he called for the destruction of all stat-
ues and non-Islamic shrines within Afghanistan: "These statues
have been and remain shrines of unbelievers and these unbelievers
continue to worship and respect them. God Almighty is the only
real shrine and all fake idols should be destroyed."[58]

Over the objections of diplomats, academics, and museum pro-
fessionals (many but not all of them from the West), the Buddhas
were attacked with hammers, spades, and explosives. Daily reports
were issued by the Taliban minister of information and culture:
"The head and legs of the Buddha statues in Bamiyan were de-
stroyed yesterday," he reported on March 2. "Our soldiers are work-
ing hard to demolish the remaining parts. They will come down
soon."[59] Even a meeting between Kofi Annan, the United Nations
secretary general, and Wakil Ahmad Muttawakil, representing
Mullah Omar, couldn't prevent their destruction.

Flood is persuasive in his criticism of the Western interpretation
of the Buddhas' destruction as a return to a crude form of medi-
eval Islamic iconoclasm. And no doubt he is right that the act was
aimed less at an internal audience than a foreign one, the West
itself. Sayed Rahmatullah Hashimi, an advisor to Mullah Omar,
was cited in the *New York Times*, shortly after the Buddhas were
destroyed, as saying that their destruction was prompted by a visit
from European envoys and a representative of UNESCO offering
money to protect the Buddhas from collateral damage in the area
where the Taliban were fighting an opposition alliance:

> The scholars told them that instead of spending money on statues, why
> didn't they help our children who are dying of malnutrition? They re-
> jected that, saying, "This money is only for statues." . . . If we had wanted
> to destroy those statues, we could have done it three years ago. So why
> didn't we? In our religion, if anything is harmless, we just leave it. If

money is going to statues while children are dying of malnutrition nest door, then that makes it harmful, and we destroy it.[60]

Afghanistan was suffering under long and harsh drought conditions and economic sanctions imposed by the international community to pressure the Taliban, who were thought to be protecting Osama bin Laden, the al-Qaeda terrorist suspect. More than a million Afghans were said to be at risk of starvation. Tens of thousands were gathered in camps, in freezing conditions. One could of course be suspicious of Rahmatullah's explanation. After all, he was in the United States to meet with officials at the Department of State and the UN Security Council, seeking improved ties with the international community and an easing of sanctions. He had every reason to blame the sculptures' destruction on the West's foreign policies rather than the internal cultural politics of the Taliban (already widely criticized in the West for its harsh treatment of women).

The matter turned to museums when, in response to the Mullah Omar's edict, directed not only against the Buddhas but against all "statues and non-Islamic shrines," a number of museum leaders—and not only in the West—volunteered to bring objects at risk in Afghan museums into their collections, at least temporarily, for safekeeping. Philippe de Montebello, then director of the Metropolitan Museum of Art in New York, pleaded with the Taliban to "let us remove them so that they are cultural objects, works of art and not cult images." Mullah Omar replied, in a statement to the international Muslim community, "Do you prefer to be a breaker of idols or a seller of idols?"

During the same period, however, the Taliban evinced some interest, if brief and soon enough overturned, in cultural preservation. In 1998 Paul Bucherer-Dietschi, director of the Bibliotheca Afghanica, a Swiss foundation created in 1975 as a center of documentation on Afghanistan, received a request from both the Taliban and the Northern Alliance to establish a safe despository in Switzerland for the protection of Afghan cultural artifacts. A year later,

a "museum-in-exile" was proposed by Bucherer-Dietschi to the Swiss ambassador to UNESCO. With funding from private donors and the Swiss federal government, the museum was established in Bubendorf in May 1999 and inaugurated in October 2000. Over the next six years, the museum received artifacts from Afghan officials and private collectors there and in the West (including Bucherer-Dietschi).[61] In 2007 some fifteen hundred of these objects were repatriated to Afghanistan at the request of the Afghan Ministry of Information and Culture.

In an interview in 2002, Bucherer-Dietschi said that "the original idea of the Afghans was to bring to Switzerland all of the holdings of the Kabul Museum and so to create primarily an archaeological museum." He first suggested that the Afghan artifacts be housed in Zurich's Rietberg Museum, which specializes in Asia art, "but the Afghans did not want their pieces mixed up with Indian, Japanese and Chinese material. Regardless of how modest a space it may be, the Afghans said they wanted their own museum to display exclusively Afghan artifacts." He blamed the destruction of the Bamiyan Buddhas on al-Qaeda:

> In December 2000, three months before the destruction of the Buddhas, I was in Kandahar and I spoke to the leaders of the Taliban, although not to Mullah Omar (he did not agree to see me since I am not a Muslim). I did however meet with the second-in-command, who demonstrated to me in different ways how the Taliban were no longer masters in their own house.... Around early January 2001, when I had meetings regarding Bamiyan with the Minister of Information of Culture, Qudratullah Jamal, [he] told me that his hands were tied.... When I was in Kabul in January 2002, I went to the storerooms of the Kabul Museum with the caretakers of the rooms who are personally responsible for every single item there, and they too told me that the destruction was done by a group of ten men, two of them Afghans, and the rest foreigners.[62]

He blamed the problem on Western sanctions, which, he said, pushed the Taliban "into the arms of al-Qaeda." Afghanistan was

of interest to al-Qaeda because of its standing in the Islamic world, having driven out the British in the nineteenth century and the Soviets in the twentieth century; if al-Qaeda could make Afghanistan predominantly Wahhabi, the Wahhabi movement would get an enormous boost among Muslims everywhere. "Afghan society was very weak after twenty years of war," he explained, and "could not put up any real resistance."

In Flood's view, "the truly global implications of this event [the destruction of the Buddhas] derive, however, from the fact that Mullah Omar's words were directed not eastward, toward the Hindus of India or the Buddhist communities beyond, but westward, toward European and American museum directors seeking to ransom the ill-fated images." Clearly, though, the situation was more complicated. It is much more likely that his words were directed beyond those museum directors to the Western governments responsible for the harsh sanctions then in place and for the increasing military activity against al-Qaeda within Afghanistan. The museum directors' plea to safeguard works of art under Taliban jurisdiction merely provided an opportunity to speak out, and then to act (and destroy much of the Kabul Museum's collection).[63]

Flood emphasizes "the awkward relation between the museum, colonization, and modernity" and "tensions between the idea of the museum as a showcase for national patrimony, the idea of art as a universal human value, and the historical collecting practices of many Euro-American museums vis-à-vis colonial and postcolonial states." This allows him to claim that Taliban iconoclasm should be understood as a "form of protest against exclusion from an international community in which the de facto hegemony of the elite nations is obscured by the rhetoric of universal values."[64] Finally, he states, "It was precisely as a reaction to the hegemonic cultural, economic, and political power of this Enlightenment tradition that the destruction of the Buddhas was undertaken." Flood does acknowledge that none of this suffices to condone the actions of any of the players in the events of March 2001, "but it is imperative to recognize that those events have a logic rooted not in the fictions

of an eternal or recurring medievalism but in the realities of global modernism."

Flood is right to reject any essentializing of Islamic culture as medieval and opposed to the West. But one should go further and use this example to champion the museum as a secular space for reasoned disputation, where connections between cultural objects contradict the popular tendency to essentialize differences wherever it occurs—in Flood's example, both the Taliban's perception of the imperializing West and the erroneous, totalizing views of Islam held by many in the West. The encyclopedic museum, with representative examples of the world's many cultures, including images and objects that were once (and may still be) viewed as sacred, as well as those that were always secular, is a site for the kind of work Edward Said holds as fundamental to all humanist inquiry: "to complicate and/or dismantle the reductive formulae and abstract but potent kind of thought that leads the mind away from concrete human history and experience and into the realms of ideological fiction, metaphysical confrontation and collective passion."[65]

The question is, who has authority over an object's meaning— the encyclopedic museum or the "originating" culture? "The important thing," Bucherer-Dietschi said,

> is that the protection of cultural heritage should not be abused in a colonial kind of way. We should accept that this cultural heritage is the cultural heritage of the Afghan people. They are proud of it. We too, from the West may like it, may give our support to protect it, but it does not belong to us. It is not up to us to decide what has to be done. The Afghans are able and ready to decide. They will ask our advice but in the end they will decide for themselves.[66]

That is the sad truth. Nationalized cultural property within the jurisdiction of the nation-state is the state's to do with as it pleases. There is nothing anyone else can do, not even UNESCO. Opponents of repulsive state action, like the Taliban's destruction of the Bamiyan Buddhas and much of the Kabul Museum's collection, can only protest.[67]

: : :

I have tried over the course of these four chapters to make the case for the importance of the encyclopedic museum—whether it be in Chicago or Delhi—as an Enlightenment institution dedicated to a cosmopolitan worldview and the proposition that by providing a diverse population of visitors informed access to representative examples of the world's many cultures, it can serve to dissipate ignorance about the world and promote understanding of difference itself. There are, of course, different points of view about this, and I have tried to acknowledge those that differ from my own. In this chapter, the competing view—the many, *different and divergent* views—comes from the vantage points of former colonized lands, and I acknowledge here Partha Chatterjee's point:

> My argument is that because of the way in which the history of our modernity has been intertwined with the history of colonialism, we have never quite been able to believe that there exists a universal domain of free discourse, unfettered by difference of race or nationality. Somehow, from the very beginning, we have made a shrewd guess that given the close complicity between modern knowledges and modern regimes of power, we would forever remain consumers of universal modernity; never would we be taken seriously as its producers. It is for this reason that we have tried, for over a hundred years, to take our eyes away from this chimera of universal modernity and clear a space where we might become the creators of our own modernity.[68]

The question is, of course, what *kind* of modernity? One that aspires to a cosmopolitan view of the world, or one that limits its vision and identity to "the defensive little patch offered by one's own culture, literature, and history?" After little more than six decades attempting to create and police state-based identities, with all of the concomitant civil wars, sectarian violence, and virulent cultural xenophobia that resulted, it is time to try something else, something that while acknowledging the necessary existence of the state encourages broader affiliations that express themselves

horizontally across state lines through chosen alliances among the full range of nongovernmental organizations, universities, and museums, which engage in iterative acts that, as Seyla Benhabib has described them, increase "the threshold of justification to which formerly exclusionary practices are now submitted."

As Arjun Appadurai has written:

> We need to think ourselves beyond the nation. This is not to suggest that thought alone will carry us beyond the nation or that the nation is largely a thought or an imagined thing. Rather, it is to suggest that the role of intellectual practices is to identify the current crisis of the nation and, in identifying it, to provide part of the apparatus of recognition for postnational social forms. Though the idea that we are entering a postnational world seems to have received its first airings in literary studies, it is now a recurrent (if unself-concious) theme in studies of postcolonialism, of global politics, and of institutional welfare society.[69]

And of the role of encyclopedic museums too, I would argue.

This, I hold, is what those millions of people coming to the Art Institute of Chicago in any given year want, and why, as I opened this book, they were standing in line to enter the museum on a hot summer afternoon. They want to experience the larger world, to feel a part of its rich and fecund diversity, to be ennobled by it, to feel as Cicero did: "I am a human being; I think nothing human alien to me."

"The map of the world," Edward Said once wrote, "has no divinely or dogmatically sanctioned spaces, essences, or privileges. However, we may speak of secular space, and of humanly constructed and interdependent histories that are fundamentally knowable, although not through grand theory of systematic totalization."[70] The encyclopedic museum is just such a space. It was founded on the Enlightenment principles of suspicion of unverifiable truths, opposition to prejudice and superstition, confidence in individual agency, the public exercise of reason, and the promise that critical inquiry leads to truths about the world for the benefit

of human progress and the forging of a common, pluralistic identity from our highest, most noble aspirations.

For all of this, the encyclopedic museum should be preserved where it exists today and encouraged where it does not yet exist. This will take trust, compromise, and understanding by all parties in all corners of the postcolonial world. But it must be done, precisely because so much is at stake.

Homi Bhabha once told me that when he went away to university in Oxford, he found life there provincial compared to Bombay, where he had lived and first studied: "There was something about the active hybridization of cultural practices and values in Bombay that made the city, its conversations and confluences, remarkably invigorating. Oxford seemed pallid and self-protective."[1] Relations between imperial center and imperialized periphery are not so simple.

The cultural foundations of an independent India were of imperial origin. The Asiatic Society, founded by a British civil servant, continues today, with an ambitious program of research activities in the sciences and humanities, supported by a library, museum, and publications program. The Archaeological Survey of India, proposed by an East India Company military engineer, remains the authoritative agency for all matters related to archaeology, antiquities, and site museums in India. India's cultural property regime was established by the British and is still the basis for India's definition of control over what it claims to be its cultural legacy. Even the National Museum of India is based in great part on the work

of a British government committee, which in 1946 offered a blue-print for a "Central National Museum of Art, Archaeology and Anthropology" to be set on a central New Delhi site at the Kingsway-Queensway crossing.

It is often said that the knowledge-producing project of the British Empire was an instrument of control. In Gyan Prakash's formulation:

The beginnings of science's cultural authority in India lie in the "civilizing mission" introduced by the British in the early nineteenth century. It was then that colonial rule began to manifest a distinct shift from its late-eighteenth-century modality. As the East India Company consolidated its territorial control, it slowly shed its character as a body of traders whose eyes were on quick and ill-gotten profits, and settled down to fashion a despotism aimed at developing and exploiting the territory's resources efficiently and systematically.... As the British produced detailed and encyclopedic histories, surveys, studies, and censuses, and classified the conquered land and people, they furnished a body of empirical knowledge with which they could represent and rule India as a distinct and unified space. Constituting India through the empirical sciences went hand and hand with the establishment of a grid of modern infrastructures and economic linkages that drew the unified territory into the global capitalistic economy.[2]

Indian museums under British rule—whether focused on archaeology, natural or economic history, or industrial or fine arts—were part and parcel of this knowledge production. But their story is more complex. The Archaeological Survey of India continues as a centralized institution, scientifically gathering knowledge, controlling its production through state-sanctioned excavations and publications, and policing access to important monuments and archaeological artifacts, whether held publicly or privately. Its director general even has the power "to decide whether any article, object or thing is or is not an antiquity for the purposes of this Act" (the Antiquities Export Control Act of 1947). And the National Museum of India is the author of independent India's national artistic

narrative and canon. Knowledge-control is a function of the state, whether imperial or republican.

That said, control is not and never has been absolute. However much the imperial capital in Calcutta or the republic's capital in New Delhi has sought control, museums on the periphery often resist it. Kavita Singh has written of Indian state museums as evidence of the growing independence of the Princely States from centralized British control during the Raj. She refers to Rudyard Kipling's pointed praise of Jaipur's Central Museum and his call to the

> Governments of India, from Punjab to Madras! The doors come true to the jamb, the cases which have been through hot weather are neither warped nor cracked, nor are there unseemly tallow-drops and flaws in the glasses.... These things are so because money has been spent on the Museum, and it is now a rebuke to all other museums in India, from Calcutta downwards ... [a museum] built, filled and endowed with royal generosity—an institution perfectly independent of the Government of India ...[3]

Singh suggests that Kipling might here be venting some of his father's spleen, who as curator of the Lahore Museum had to function with limited funds and cumbersome, centralized imperial bureaucracy.

Singh questions the whole center-local paradigm with regard to museums in India. She points out that the earliest museums—in Calcutta, Madras, and Bombay—were started not by government but by amateurs (the Asiatic Society in Calcutta and Madras, in the latter case with the involvement of the Madras Literary Society). Only when these early museums' collections became large and unwieldy did they appeal to the government to take them over and maintain them: the museum in Madras was taken over by the East India Company administration in 1851, as was Calcutta's in 1865 (it had first appealed in 1814); Bombay's Victoria and Albert Museum (now the Dr. Bhau Daji Lad Museum) remained independent until 1886, when the city took it over. It is only with the British Raj that there emerge the beginnings of a coherent museum policy for India. And it, Singh notes, was principally concerned with the mu-

seums' potential for encouraging economic and industrial production. In 1882 the secretary to the Home Department responsible for such museums wrote in his report, "The main object . . . is not the gratification of occidental curiosity, or the satisfaction of aesthetic longings among foreign nations, but a development of a trade in these products, whether raw or manufactured, rough or artistic."[4]

During the Raj, while there emerged government support for archaeological, scientific, economic, and industrial arts museums and collections, there was far less attention given to the fine arts. That fell to private citizens and the princely courts. The purchase by Sayayji Rao of Baroda of a large collection of European paintings should not be read, Singh argues, "as a slavish imitation of European practices, the half-heartedness and insincerity of colonial progressivism."[5] It was instead a manifestation of his progressive vision of rulership. He built his museum, filled it with wondrous things from many historical periods and cultures, and opened it to the public. "What is most significant about Sayaji Rao's act of making his collection," Singh writes, "is that he alone in India invested in purchasing the best European art and then gifted it to his public. For all the claims made by the British about the superiority of Western over Eastern art, on the one hand, and their professed desire to educate and civilize Indians, on the other, they nowhere attempted to give their Indian citizens access to high European culture."

This is a damning assessment of the imperial museum enterprise in India. It would fall to the maharajahs under the Raj and to private individuals under the empire (like the Tatas, who in 1921 and 1933 donated their collections of Tibetan, Nepalese, Japanese, and Chinese art and European paintings to the Prince of Wales Museum, and thus to the citizens of Bombay) to embrace the promise of the encyclopedic museum as first constituted in the British Museum and as I have defined it here. The imperial museums failed in this regard, and the national museums have done no better. They each looked back and defined their India in narrow, politically determined terms. They didn't embrace the world of which India has always been a part. And the unified construction of their "India" did not and cannot hold.

Neil MacGregor points out that the museum can be a place where dialogues and debates occur that cannot occur in temples or mosques. The latter are self-interested institutions, dedicated to the formulation of a particular worldview defined precisely as not another's. The museum, on the other hand, and especially the encyclopedic museum, aspires to the condition of disinterestedness as a secular site for individual exploration and public conversation *about* difference in the world. It presents evidence of such difference—things that bear the imprint of difference, as well as the markings of cultural hybridity—and then subjects that evidence to scientific examination and offers it up for public consideration. In the postnational world in which we live, in which religious revivalism and cultural nationalism are hardening essentialized differences between people, such sites offer the best hope for tolerance and understanding of difference. Religious and cultural sites, on the other hand, are often places of fierce contest and intolerance. Consider once again the controversy over the Babri Mosque.

Tapati Guha-Thakurta points out that the destruction of the mosque was more than an attack on a particular building or on Muslim sentiments. It was an attack on the Indian government's claim that the building was cultural property, part of the heritage of India, to be protected as a monument of historical and archaeological importance for all Indians. And at issue in debates following the attack was trust in the scientific truth of archaeological evidence.[6]

From the beginning, the demand by the right-wing Vishva Hindu Parishad (VHP) that a temple be built on the site was based on a "mass of literary, historical, archaeological and judicial evidence" for the existence of an earlier temple marking Rama's birthplace, which it presented to the government of India in 1990.[7] This was intended to refute the counterevidence presented by the Centre for Historical Studies of Jawaharlal Nehru University in 1989.[8] As the debate raged on, with neither side convincing the other, one archaeologist, B. P. Sinha, pointed out that archaeological evidence itself is insufficient in the face of belief: "For hundreds of years, if not thousands, the Hindus have *believed* this site to be the birthplace of their divine Lord Rama," and it is misguided to

"whisk away such long-held pious belief of millions with . . . tons of weighty polemics."

Romila Thapar, a leading figure on the left/secular side of the debate, replied:

> What is at issue is the attempt to give historicity to what began as a belief. Whereas anyone has a right to his or her beliefs, the same cannot be held for a claim to historicity. Such a claim has to be examined in terms of the evidence, and *it has to be discussed by professionals.* . . . Historicity . . . cannot be established in a hurry and, furthermore, has always to be viewed in the context of possible doubt. Archaeology is not a magic wand, which in a *matter of moments* conjures up the required evidence. Such "instant" archaeology may be useful as a *political* gambit, but creates a sense of unease among professional archaeologists.[9]

Destruction of the mosque and the clearing of the land by the government made difficult if not impossible the task of justifying archaeological interpretations through stratigraphic analysis. What remained were fragments, which were marshaled as evidence by both sides, historical accounts that could be used to the advantage of either side, and myth and memory, which would never allow the side represented by the VHP to accept the evidence and arguments of the other. Neither politicized belief nor academic archaeology could sustain attempts at knowledge-control. Ultimately what did—*for now*—was the government, specifically the courts. The judges voted, determined the truth of the conflicting claims, and split the baby. The contesting parties, whose edifices were said to have been built one atop another, the mosque atop the temple, were instructed to cohabit side by side. Prospects of a peaceful coexistence are not promising.

: : :

Homi Bhabha reminds us that "postcolonial civil societies are profoundly cosmopolitan, having weathered the incursions and impositions of 'international' cultural and market forces prior to encoun-

tering their own 'nationalist' moments. . . . That is precisely Frantz
Fanon's point when he argues that, despite global inequalities and
injustices, it is difficult to act ethically in the national interest with-
out taking a larger view on international well-being."[10] This should
be a lesson for all of our museums and a reason to aspire to the con-
dition of the encyclopedic. It is what I have argued throughout this
book: that encyclopedic museums, born of the Enlightenment, can
encourage a curiosity about and understanding of difference in the
world; that difference has always been and has inspired and left its
mark on works of art from every culture; and that by promoting
understanding of these basic truths about culture and history, mu-
seums can encourage tolerance of difference itself.

The example of India is evidence of the need to cultivate a cos-
mopolitan view of the world and encourage cultural institutions
to support it. The British, having launched the quintessential cul-
tural institution—the encyclopedic museum—exploited India eco-
nomically, deprived its citizens of self-determination (withdrawing
only after decades of protests and violent confrontations), and es-
tablished many of its lasting cultural institutions. But they failed
to give India what Britain enjoyed for itself, and what others have
since emulated: museums with representative examples of the
world's cultures, committed to scientific inquiry, open to the public
and respectful of individual agency, and dedicated to the dissipa-
tion of ignorance about the world. The absence of such museums,
except for the few small but noble ones established locally, is part of
the tragic legacy of empire in India.

NOTES

INTRODUCTION

1. *Art Newspaper* (April 2010), 23; "AAMD 2009 Statistical Survey," http://www.aamd.org.

2. Carol Duncan and Alan Wallach, "The Universal Survey Museum," *Art History* 3, no. 4 (December 1980): 457. Duncan will develop this criticism in her *Civilizing Rituals: Inside Public Art Museums* (London: Routledge, 1995).

3. Tony Bennett, *The Birth of the Museum: History, Theory, Politics* (London: Routledge, 1995), 95.

4. In just four recent books, anthologies marketed as texts for museum studies and cultural studies courses, almost 2,500 pages and 162 articles are dedicated to "reinventing" the museum. See Donald Preziosi and Claire Farago,eds., *Grasping the World: The Idea of the Museum* (Aldershot: Ashgate, 2004); Bettina Messias Carbonell, ed., *Museum Studies: An Anthology of Contexts* (Oxford: Blackwell, 2004); Sharon Macdonald, ed., *A Companion to Museum Studies* (Oxford: Blackwell, 2006); and Gail Anderson, ed., *Reinventing the Museum: Historical and Contemporary Perspectives on the Paradigm Shift* (Walnut Creek, CA: Alta Mira Press, 2004). For a review of recent literature, see Andrew McClellan, "Museum Studies Literature," *Art History* 303, no. 4 (September 2007): 566–70. McClellan himself has added to the growing list of museum studies course books. See Andrew McClellan, ed., *Art and Its Publics: Museum Studies at the Millennium* (Oxford: Blackwell Publishing, 2003) and *The Art Museum, from Boullée to Bilbao* (Berkeley: University of California Press, 2008).

5. On the early history of Chicago, see Dominic A. Pacyga, *Chicago: A Biogra-*

phy (Chicago: University of Chicago Press, 2009), and James R. Grossman, Ann Durkin Keating, and Janice L. Reiff, eds. *The Encyclopedia of Chicago* (Chicago: University of Chicago Press, 2004).

6. Daniel H. Burnham and Edward H. Bennett, *Plan of Chicago*, ed. Charles Moore (Princeton: Princeton University Press, 1993), 110–11.

7. See http//quickfacts.census.gov/qfd/stats/17/1714000.html.

8. The same principle was stated by Condorcet ("We must have the courage to examine everything") and Diderot ("All facts are equally subject to criticism"), among others, as quoted in Tzvetan Todorov, *In Defence of the Enlightenment*, trans. Gila Walker (London: Atlantic Books, 2009), 42. I will return to Todorov and contemporary defenses of the Enlightenment in chapter 1.

9. Roxanne L. Euben, *Journeys to the Other Shore: Muslim and Western Travelers in Search of Knowledge* (Princeton: Princeton University Press, 2006), 196.

10. Edith Grossman, *Why Translation Matters* (New Haven: Yale University Press, 2010), xi.

11. Edward W. Said, *Culture and Imperialism* (London: Vintage Books, 1994), 49.

CHAPTER ONE

1. Zeev Sternhell, *The Anti-Enlightenment Tradition*, trans. David Maisel (New Haven: Yale University Press, 2010), 41.

2. See Andrew McClellan, *Inventing the Louvre: Art, Politics, and the Origins of the Modern Museum in Eighteenth-Century Paris* (Cambridge: Cambridge University Press, 1994); Thomas W. Gaehtgens, *Die Berliner Museumsinsel im Deutschen Kaiserreich: Zur Kulturpolitik der Museen in der wilhelminischen Epoche* (München: Deutscher Kunstverlag, 1992); and Geraldine Norman, *The Hermitage: The Biography of a Great Museum* (New York: Fromm International, 1998).

3. See Arthur MacGregor, ed., *Sir Hans Sloane, Collector, Scientist, Antiquary, Founding Father of the British Museum* (London: British Museum Press, 1994); Marjorie L. Caygill, "From Private Collection to Public Museum: The Sloane Collection at Chelsea and the British Museum in Montagu House," in *Enlightening the British: Knowledge, Discovery and the Museum in the Eighteenth Century*, ed. R. G. W. Anderson, M. L. Caygill, A. G. MacGregor, and L. Syson (London: British Museum Press, 2003), 18–28; Kim Sloan, "'Aimed at universality and belonging to the nation': The Enlightenment and the British Museum," in *Enlightenment: Discovering the World in the Eighteenth Century*, ed. Kim Sloan (London: British Museum Press, 2003), 12–25; and Marjorie Caygill, *The Story of the British Museum* (London: Museum Publications, 1981).

4. MacGregor, *Sir Hans Sloane*, 31–34.

5. Marjorie Caygill, "Sloane's Will and the Establishment of the British Museum," in MacGregor, *Sir Hans Sloane*, 45–68.

6. *Le Moniteur*, 14:263, cited in McClellan, *Inventing the Louvre*, 91–92.

7. For his articulation of the purpose of the British Museum, see Neil MacGregor, "To Shape the Citizens of 'That Great City, the World,'" in *Whose Cul-*

ture? The Promise of Museums and the Debate over Antiquities, ed. James Cuno (Princeton: Princeton University Press, 2009). Also see Neil MacGregor, "The Whole World in Our Hands" (review), *Guardian* (July 24, 2004), 5-7.

8. See Bengt Jonsell, "Linnaeus, Solander and the Birth of the Global Plant Taxonomy," in Anderson et al., *Enlightening the British*, 92-99.

9. Albrecht Dürer, *The Writings of Albrecht Dürer*, trans. and ed. William Martin Conway (New York: Philosophical Library, 1958), 101-2.

10. See Caygill, *Story of the British Museum*.

11. See Luke Syson, "The Ordering of the Artificial World: Collecting, Classification and Progress," in Sloan, *Enlightenment*, 108-21.

12. As quoted in ibid., 120.

13. Roy Porter, *Enlightenment: Britain and the Creation of the Modern World* (London: Penguin Books, 2000), 92. Also see John Considine, *Dictionaries in Early Modern Europe* (Cambridge: Cambridge University Press, 2008); Robert DeMaria Jr., *Johnson's Dictionary and the Language of Learning* (Oxford: Clarendon Press, 1986); Frank A. Kafker, ed., *Notable Encyclopedias of the Seventeenth and Eighteenth Centuries* (Oxford: Voltaire Foundation at the Taylor Institution, 1981); and Robert Collison, *Encyclopedias* (New York: Hafner, 1964).

14. Robert Darnton, *Business of Enlightenment* (Cambridge: Harvard University Press, 1979), 12

15. Porter, *Enlightenment*, 86, 92, 81, 86.

16. Ibid., 20.

17. John Brewer, *The Pleasures of the Imagination: English Culture in the Eighteenth Century* (New York: Farrar, Straus Giroux, 1997), 3.

18. Ibid., 37.

19. In addition to marrying into wealth, Sloane was a prominent and fashionable physician, a member the College of Physicians of Edinburgh and president of the College of Physicians in London, Physician Extraordinary to Queen Anne and later to George I, Physician Ordinary to George II, Physician General to the Army, secretary and eventually president of the Royal Society, foreign associate of the French Académie Royale des Sciences, and a member of the Royal Prussian Academy of Sciences and the academies of sciences in St. Petersburg, Madrid, and Göttingen. In 1716 he was created a baronet, one of the first physicians to receive a hereditary title. His greatest, most lasting contribution to science was the collection he built, cataloged, and gave to the nation. See MacGregor, *Sir Hans Sloane*, 11-44.

20. Quoted in Porter, *Enlightenment*, 88.

21. Ibid., 94.

22. Alan Wolfe, *The Future of Liberalism* (New York: Alfred A. Knopf, 2009), 14.

23. Hans Reiss, "Introduction," in Immanuel Kant, *Kant: Political Writings*, ed. Reiss (Cambridge: Cambridge University Press, 2009), 25. Also see Jürgen Habermas, "On the Internal Relation between the Rule of Law and Democracy," in Habermas, *The Inclusion of the Other: Studies in Political Theory*, ed. Ciaran Cronin and Pablo De Greiff (Cambridge: MIT Press, 1998), 258-59.

24. Thomas Jefferson, "Declaration of Independence," in Lynn Hunt, *Inventing Human Rights* (New York: W. W. Norton, 2007), 216.

25. "Declaration of the Rights of Man and Citizen," in Hunt, *Inventing Human Rights*, 221.

26. For example, in 1791 the revolutionary French government granted equal rights to Jews and some free blacks; in 1792 even men without property were included. In 1794 it officially abolished slavery and at least in principle extended equal rights to former slaves. See Hunt, *Inventing Human Rights*, 28. The legacy of Enlightenment republicanism is apparent too in more recent documents. The United Nations' 1945 charter imposes on member states a general obligation to respect and promote human rights, which were enumerated in 1948 in its Universal Declaration of Human Rights, which begins, "Whereas recognition of the inherent dignity and of the equal and inalienable rights of all members of the human family is the foundation of freedom, justice and peace in the world . . ." Ibid., 223. Human Rights Watch, founded in 1978 as Helsinki Watch, which supported citizen groups monitoring compliance with the Helsinki Accords throughout the Soviet bloc, declares in its mission statement, "We challenge governments and those who hold power to end abusive practices and respect international human rights law." See http://www.hrw.org. Also see Habermas, "Kant's Idea of Perpetual Peace: At Two Hundred Years' Historical Remove," in Habermas, *Inclusion of the Other*, 165-201.

27. Immanuel Kant, "An Answer to the Question: 'What is Enlightenment?'" in Reiss, *Kant: Political Writings*, 54.

28. Ibid., 55.

29. Clifford Siskin and William Warner, eds., *This Is Enlightenment* (Chicago: University of Chicago Press, 2010), 16.

30. Michel Foucault, "What Is Enlightenment?" in *The Foucault Reader*, ed. Paul Rabinow (New York: Pantheon, 1984), 42.

31. Michel Foucault, "Truth and Power," in Rabinow, *Foucault Reader*, 61.

32. Dipesh Chakrabarty, *Habitations of Modernity: Essays in the Wake of Subaltern Studies* (Chicago: University of Chicago Press, 2002), 24. Also see Gyan Prakash, *Another Reason: Science and the Imagination of Modern India* (Princeton: Princeton University Press, 1999). I return to this in chapter 4.

33. See Dorinda Outram, *The Enlightenment*, 2nd ed. (1995; Cambridge: Cambridge University Press, 2005); Porter, *Enlightenment*; John Robertson, *The Case for the Enlightenment: Scotland and Naples 1680-1760* (Cambridge: Cambridge University Press, 2005); William Clark, Jan Golinski, and Simon Shaffer, eds., *The Sciences in Enlightened Europe* (Chicago: University of Chicago Press, 1999); Sarah Knott and Barbara Taylor, *Women, Gender, and Enlightenment* (New York: Palgrave McMillan, 2005); Karen O'Brien, *Women and Enlightenment in Eighteenth-Century Britain* (Cambridge: Cambridge University Press, 2009); Charles W. J. Withers, *Placing the Enlightenment: Thinking Geographically about the Age of Reason* (Chicago: University of Chicago Press, 2007); J. J. Clarke, *Oriental Enlightenment: The Encounter between Asian and Western Thought* (London:

Routledge, 1997); Daniel Carey and Lynn M. Festa, *The Postcolonial Enlightenment: Eighteenth-Century Colonialism and Postcolonial Theory* (Oxford: Oxford University Press, 2009); Ziad Elmarsafy, *The Enlightenment Quran* (Oxford: Oneworld, 2009); Karen O'Brien, *Narratives of Enlightenment: Cosmopolitan History from Voltaire to Gibbon* (Cambridge: Cambridge University Press, 1997); and Alan Charles Kors, *Encyclopedia of the Enlightenment* (Oxford: Oxford University Press, 2003). The director of the Re:Enlightenment Project, Clifford Siskin, is the editor, with William Warner, of *This Is Enlightenment* (cited above), which was generated by a 2007 conference at New York University, "Mediating Enlightenment Past and Present." See http://www.reenlightenment.org. There is even the "Electronic Enlightenment," a growing online resource produced by the Bodleian Libraries at Oxford University, which to date includes 58,555 letters and documents by 7,133 correspondents "that marked the birth of the modern world." See http://www.e-enlightenment.com.

34. Tzvetan Todorov, *In Defence of the Enlightenment*, trans. Gila Walker (London: Atlantic Books, 2009).

35. See Robert O. Paxton, "Can You Really Become French?" *New York Review of Books* (April 9, 2009), 52–56; the article reviews Patrick Weil, *How to Be French: Nationality in the Making since 1789*, trans. Catherine Porter (Durham: Duke University Press, 2008), and Jonathan Laurence and Justin Vaisse, *Integrating Islam: Political and Religious Challenges in Contemporary France* (Washington, DC: Brookings Institution Press, 2006).

36. Todorov, *In Defence of the Enlightenment*, 23, 13–14.

37. Reiss, "Introduction," 25.

38. Reiss, "Introduction," 34, and Kant, "Idea for a Universal History with a Cosmopolitan Purpose" (1784), in Reiss, *Kant: Political Writings*, 41–53.

39. Todorov, *In Defence of the Enlightenment*, 122–23, 127.

40. Ibid., 143–44.

41. Sternhell, *Anti-Enlightenment Tradition*, 49.

42. Ibid., 101.

43. Ibid., 16.

44. Ibid., 101, 104.

45. Ibid., 195.

46. Ibid., 304.

47. Ibid., 443.

48. Todorov, *In Defence of the Enlightenment*, 151.

49. MacGregor, "To Shape the Citizens," 40.

CHAPTER TWO

1. Vladimir Nabokov, *Transparent Things* (1972; New York: Vintage, 1989), 1, cited in Bill Brown, *A Sense of Things: The Object Matter of American Literature* (Chicago: University of Chicago Press, 2003), 7.

2. Cited in Marjorie Caygill, "Sloane's Will and the Establishment of the British Museum," in Arthur MacGregor, ed., *Sir Hans Sloane: Collector, Scientist, An-*

tiquary, Founding Father of the British Museum (London: British Museum Press, 1994), 55.

3. Cited in Marjorie Caygill, "From Private Collection to Public Museum: The Sloane Collection at Chelsea and the British Museum in Montagu House," in *Enlightening the British: Knowledge, Discovery and the Museum in the Eighteenth Century*, ed. R. G. W. Anderson, M. L. Caygill, A. G. MacGregor, and L. Syson (London: British Museum Press, 2003), 20.

4. Svetlana Alpers, "The Museum as a Way of Seeing," in *Exhibiting Cultures: The Poetics and Politics of Museum Display*, ed. Ivan Karp and Steven D. Levine (Washington, DC: Smithsonian Institution, 1991), 32.

5. Ira Jacknis, "Franz Boas and Exhibits," in George W. Stocking Jr., *Objects and Others: Essays on Museums and Material Culture* (Madison: University of Wisconsin Press, 1985), 79.

6. Ibid., 91–94.

7. Brown, *Sense of Things*, 94.

8. Jacknis, "Franz Boas and Exhibits," 101, 102.

9. Ibid., 108.

10. Steven Conn, *Museums and American Intellectual Life, 1876–1926* (Chicago: University of Chicago Press, 1998), 31.

11. Brown, *Sense of Things*, 126.

12. Paul Valéry, "The Problem of Museums," in *Degas. Manet. Monet*, trans. David Paul (New York: Pantheon Books, 1960), 202.

13. Ibid.

14. See John Elderfield, ed., *Imagining the Future of the Museum of Modern Art*, Studies in Modern Art 7 (New York: Museum of Modern Art, 1998).

15. Varnedoe, in Elderfield, *Imagining the Future*, 32.

16. Taylor, in ibid., 34–35.

17. Tschumi, in ibid., 41–42.

18. Serra, in ibid., 48.

19. Gopnik, in ibid., 44.

20. Michael Baxandall, "Exhibiting Intention: Some Preconditions of the Visual Display of Culturally Purposeful Objects," in Karp and Levine, *Exhibiting Cultures*, 34.

21. This has coincided with the rise of postmodern theory; growth in museum, cultural, and visual studies programs (what the cultural anthropologist Sharon Macdonald calls "one of the most genuinely multi- and increasingly inter-disciplinrary areas of the academy today"; "Expanding Museum Studies: An Introduction," in *A Companion to Museum Studies*, ed. Macdonald [Oxford: Blackwell Publishing, 2006], 1); and the "new museology" (concerned with the "purposes" of museums rather than the "how" of museum practice; see Peter Vergo, ed., *The New Museology* [London: Reaktion Books, 1989]).

22. Carol Duncan and Alan Wallach, "The Universal Survey Museum," *Art History* 3, no. 4 (December 1980), 450. Also see Duncan, "Art Museums and the

Ritual of Citizenship," in Karp and Levine, *Exhibiting Cultures*, 88–103; and Duncan, *Civilizing Rituals: Inside Public Art Museums* (London: Routledge, 1995).

23. Ibid., 451.

24. Ibid., 457, 449.

25. Tony Bennett, *The Birth of the Museum: History, Theory, Politics* (London: Routledge, 1995), 94, 95.

26. Donald Preziosi, "Brain of the Earth's Body: Museums and the Framing of Modernity," in *Museum Studies: An Anthology of Contexts*, ed. Bettina Messias Carbonell (Oxford: Blackwell, 2004), 76.

27. Ibid., 82.

28. Donald Preziosi, "Art History and Museology: Rendering the Visible Legible," in Macdonald, *Companion to Museum Studies*, 56.

29. Donald Preziosi, "Museology and Museography," in "A Range of Critical Perspectives: The Problematics of Collecting and Display, Part I," *Art Bulletin* (March 1995), 13–15.

30. In their expansive recent anthology, *Grasping the World: The Idea of the Museum*, Preziosi and his coeditor, Claire Farago, write with confidence from a place in "the post-Enlightenment world." Their task is "to plot a critical, historical, and ethical understanding of the practices centered on what we commonly understand today about museums as a key force in the fabrication and maintenance of modernity." For them museology, colonialism, and imperialism ("and their consequent moral, social, and epistemological effects and affordances") are inseparable. The invention of the museum, they note, coincides with the epistemic paradigm shift that engaged Foucault's attention (and Bennett's). And so "museums serve as theater, encyclopedia, and laboratory for stimulating (demonstrating) all manner of casual, historical, and (surreptitiously) teleological relationships." And they "function as diagnostic devices and modular measures for making sense of all possible worlds and their subjects." In their view, the institution of the museum has "fundamentally transformed the world" by serving as "staged environments that elicit our selves and locate and orient our desires within the trajectories of an imagined past." See Preziosi and Farago, eds., *Grasping the World: The Idea of the Museum* (Aldershot: Ashgate, 2004), 1–8.

The differences between how these university-based critics see the museum and how we who work in museums see them is reminiscent of the divide between "the two art histories" that developed in the 1970s and 1980s and lingers still. This divide was addressed in a conference at the Sterling and Francine Clark Art Institute in 1999 and in an editorial by the editor of the *Art Bulletin*, the principal academic journal of the College Art Association. In the latter, Richard Brilliant noted that the different activities of museum and university scholars seem to be taking their practitioners further apart: "The demands of their respective roles, the arenas of their primary activity, and the public addressed by them in their professional capacity have become increasingly distinct, in a man-

ner reminiscent of C. P. Snow's 'two worlds.'" See Brilliant, "Out of Site, Out of mind" (editorial), *Art Bulletin* (December 1992), 561, and Charles W. Haxthausen, ed., *The Two Art Histories* (Williamstown, MA: Sterling and Francine Clark Art Institute, 2002).

31. Carol Duncan, "From the Princely Gallery to the Public Art Museum: The Louvre Museum and the National Gallery, London," in Preziosi and Farago, *Grasping the World*, 256.

32. See Anna Summers Cocks, "Sarkozy Presides over Louvre Abu Dhabi Groundbreaking while Launching French Military Base in the Region," *Art Newspaper* (May 20, 2009), http://www.theartsnewspaper.com. A description of the project and its purpose ("to share France's cultural heritage with the Emirate of Abu Dhabi") is on the Louvre's website, http://www.louvre.fr.

33. Duncan and Wallach, "Universal Survey Museum," 457.

34. See Stephen Bann, "The Return to Curiosity: Shifting Paradigms in Contemporary Museum Display," in *Art and Its Publics: Museum Studies at the Millennium*, ed. Andrew McClellan (Oxford: Blackwell Publishing, 2003), 120.

35. Similar mounted ewers can be found in the Victoria and Albert Museum (M.220.1916) and the Boston Museum of Fine Arts (55.471).

36. Marco Polo and Ibn Battuta quotations are from John Carswell, *Blue and White: Chinese Porcelain and Its Impact on the Western World* (Chicago: David and Alfred Smart Gallery, University of Chicago, 1985). The book is a very helpful source for an account of blue and white ware, as is the same author's *Blue and White: Chinese Porcelain Around the World* (London: British Museum Press, 2000).

37. To date, eighteen thousand sunken vessels have been discovered along the China–Middle East trade routes, five thousand of which alone sailed from just one kiln-rich Chinese city—Jingdezehen—prior to 1323. See John Guy, "Asian Trade and Exchange before 1600," in *Encounters: The Meeting of Asia and Europe, 1500–1800*, ed. Anna Jackson and Amin Jaffer (London: V&A Publications, n.d.), 60–67, and Carswell, *Blue and White* (2000), 67–70.

38. Quite early, the Chinese began making blue and white wares for the Portuguese market, include vessels decorated with Christian motifs. Indeed, the Portuguese taste for Chinese porcelain was so great that the triangular sides of the pyramid vault of a room in the De Santos palace in Lisbon are covered with 260 pieces of blue and white ware, the earliest dating from ca. 1500, the latest from the mid-seventeenth century. See Carswell, *Blue and White* (2000), 129–137.

39. See Sir Francis Watson, *Chinese Porcelain in European Mounts* (New York: China House Gallery, 1980), and Rose Kerr, "Chinese Porcelain in Early European Collections," in Jackson and Jaffer, *Encounters*, 46–51,

40. Lionel Trilling, "Mind in the Modern World," in *The Moral Obligations to Be Intelligent* (New York: Farrar Straus Giroux, 2000), 496. The Murdoch quote is taken from Elaine Scarry, *On Beauty and Being Just* (Princeton: Princeton University Press, 1999), 112. Also see my "The Object of Art Museums," in *Whose*

Muse? Art Museums and the Public Trust, ed. James Cuno (Princeton: Princeton University Press, 2004), 49–75.

41. Alan Wolfe, *The Future of Liberalism* (New York: Alfred A. Knopf, 2009), 30.

42. Stephen Greenblatt, "Resonance and Wonder," in Karp and Lavine, *Exhibiting Cultures*, 42–56.

43. Alpers, "Museum as a Way of Seeing," 31.

44. Duncan, *Civilizing Rituals*, 4.

CHAPTER THREE

1. Tony Judt, "Crossings," *New York Review of Books* (March 25, 2010), 15.

2. For four centuries after Ibn Battuta's death in 1368 his book of travels circulated in various copies among learned Arabic readers in West and North Africa and Egypt. It was unknown outside these countries until early in the nineteenth century, when two German scholars and then an Englishman published separate translations based on abridgements of the text. Around the middle of the century, five manuscripts were found in Algeria by French occupying authorities and removed to Paris and the Bibliothèque Nationale. Since then, translations have appeared in countries as far-flung as Spain, Hungary, Russia, Iran, and Japan. Numerous English translations have appeared, including a "complete" edition comprising four volumes and an index (the last published in 2001). See Ross E. Dunn, *The Adventures of Ibn Battuta: A Muslim Traveler of the Fourteenth Century* (Berkeley: University of California Press, 1989).

3. Ibid., 12–13.

4. See Marshall G. S. Hodgson, "Hemispheric Interregional History as an Approach to World History," *Journal of World History* 1 (1954): 715–23, and Hodgson, *The Venture of Islam: Conscience and History in a World Civilization*, 3 vols. (Chicago: University of Chicago Press, 1974). Also see William H. McNeill, *The Rise of the West: A History of the Human Community* (Chicago: University of Chicago Press, 1963).

5. Roxanne L. Euben, *Journeys to the Other Shore: Muslim and Western Travelers in Search of Knowledge* (Princeton: Princeton University Press, 2006), 87, 88.

6. Muhammad Bamyeh, "Global Order and the Historical Structures of *Dar al-Islam*," in Manfred Steger, ed., *Rethinking Globalism* (Lanham, MD: Rowan and Littlefield, 2004), 223.

7. Xuanzang was a seventh-century Buddhist monk who during the Tang Dynasty traveled from Xian to India and back, gathering Buddhist scriptures and recording his observations and experiences along the way. Wilfred Thesiger was a mid-twentieth-century English writer, born in Addis Ababa, Ethiopia, whose books on the Bedouins of the "Empty Quarter" of Arabia and the Marsh Arabs of southern Iraq are, with no exaggeration, among the best travel accounts ever written. Ryszard Kapuścínski was a late-twentieth-century Polish journalist who wrote revealingly of the decline of Haile Selassie's reign in Ethiopia, the fall of the Shah in Iran, and the last days of the Soviet Union. His books *Trav-*

els with Herodotus (2007) and *The Other* (2008) are part memoir and part re-
flection on the merits of travel. And V. S. Naipaul is the Trinidad-born, Nobel
Prize-winning novelist of Indian descent, whose revelatory and controversial
travel books—*Among the Believers* (1981), *India: A Million Mutinies Now* (1990),
and *Beyond Belief* (1998)—are richly textured accounts of his confrontations
with nationalism, fundamentalism, and postcolonial life in the Middle East and
India. On travel and the comparative study of literature, see chapter 4.

8. Paul Ricoeur, *History and Truth* (Evanston, IL: Northwestern University
Press, 1965), 278.

9. Euben, *Journeys to the Other Shore*, 10.

10. Vinay Dharwadker, "A. K. Ramanujan's Theory and Practice of Transla-
tion," quoted in Finbarr B. Flood, *Objects of Translation: Material Culture and
Medieval "Hindu-Muslim" Encounter* (Princeton: Princeton University Press,
2009), 3.

11. Edith Grossman, *Why Translation Matters* (New Haven: Yale University
Press, 2010), 14.

12. Richard Rorty, "Cosmopolitanism without Emancipation: A Response to
Jean-François Lyotard," in *Objectivism, Relativism, and Truth, Philosophical Papers*
(Cambridge: Cambridge University Press, 1991), 1:213; Kwame Anthony Appiah,
Cosmopolitanism: Ethics in a World of Strangers (NY: W. W. Norton, 2006), xv.

13. Euben, *Journeys to the Other Shore*, 1.

14. See Barbara Plankensteiner, "Introduction," in *Benin Kings and Rituals:
Court Arts from Nigeria*, ed. Plankensteiner (Vienna: Kunsthistorisches Museum,
2007), 21-39.

15. See Osarhieme Benson Osadolor, "Warfare, Warriors and Weapons in
the Pre-Colonial Kingdom of Benin," in Plankensteiner, *Benin Kings and Rituals*,
73-82.

16. Kathleen Bickford Berzock, "Talismanic Textile," in *The Silk Road and
Beyond: Travel, Trade, and Transformation*, ed. Karen Manchester (Chicago: Art
Institute of Chicago, 2007), 87-88.

17. Tanya Treptow, "Bhaishajyaguru Mandala," in Manchester, *Silk Road*, 78.
Also see Pratapaditya Pal, ed., *Himalayas: An Aesthetic Adventure* (Chicago: Art
Institute of Chicago, 2003), 190-93.

18. For many of the factual details that follow, I have relied on Brenda Rich-
ardson, *Brice Marden: Cold Mountain* (Houston: Houston Fine Art Press), 1992.

19. Yoshiaki Shimizu and John M. Rosenfield, *Master of Japanese Calligraphy,
8th-19th Century* (New York: Asia Society Galleries and Japan House, 1984).

20. *The Collected Songs of Cold Mountain*, trans. Red Pine, with an introduc-
tion by John Blofeld (Port Townsend, WA: Copper Canyon Press, 1983).å

21. Han Shan, "Cold Mountain Poem 81," in *Classical Chinese Poetry: An An-
thology*, trans. and ed. David Hinton (New York: Farrar Straus Giroux, 2008), 216.

22. Richardson, *Brice Marden*, 76.

23. The portfolio, "Etchings to Rexroth," was published by Peter Blum Edi-
tion in 1986. The letterpress book edition appeared the same year: *Thirty Six*

Poems by Tu Fu, Translated by Kenneth Rexroth with Twenty-Five Etchings by Brice Marden, intro. Bradford Morrow (New York: Peter Blum Edition, 1986).

24. For examples of the photographs, see Richardson, *Brice Marden*, 61–63.

25. In ibid., 70.

26. From Pat Steir, "Brice Marden: An Interview," in *Brice Marden: Recent Drawings and Etchings* (New York: Matthew Marks, 1991), as quoted in Richardson, *Brice Marden*, 51–52.

27. For an assessment of Ni Zan's work, see James Cahill, "The Yuan Dynasty (1271–1368)," in *Three Thousand Years of Chinese Painting*, ed. Yang Xin, Nie Chongzheng, Lang Shaojun, et al. (New Haven: Yale University Press, 1997), 169–75.

28. Maxwell K. Hearn, *How to Read Chinese Paintings* (New York: Metropolitan Museum, 2008), 98–105; Cahill, "Yuan Dynasty," 173.

29. Ibid., 98.

30. Ibid., 4, 78–87.

31. James Cahill, "Approaches to Chinese Painting, Part II," in Yang Xin, Nie Chongzheng, Lang Shaojun, Richard M. Barnhart, James Cahill, and Wu Hung, *Three Thousand Years of Chinese Painting* (New York: Yale University Press, 1997), 10.

32. Han Shan, "Cold Mountain Poem 28," in Hinton, *Classical Chinese Poetry*, 215.

33. Grossman, *Why Translation Matters*, 8–9.

34. Ibid., 71.

35. Ibid. 23.

36. I am reminded of the novelist Martin Amis's remark about the importance to him of Saul Bellow's work: "I see Bellow perhaps twice a year, and we call, and we write. But that accounts for a fraction of the time I spend in his company. He is on the shelves, on the desk, he is all over the house, and always in the mood to talk. That's what writing is, not communication but a means of communion. And here are the other writers who swirl around you, like friends, patient, intimate, sleeplessly accessible, over centuries. This is the definition of literature." Amis, *Experience* (New York: Talk Miramax Books, 2000), 268.

37. James Cuno, *Who Owns Antiquity? Museums and the Battle Over Our Ancient Heritage* (Princeton: Princeton University Press, 2008)

38. Flood, *Objects of Translation*, 9.

39. Bamyeh, "Global Order," 218.

40. In 1784 Kant published "Idea for a Universal History with a Cosmopolitan Purpose" in the *Berliner Monnatsschraft*, the same year as he wrote "What is Enlightenment?" In 1795 he published the lengthy treatise *Perpetual Peace*. Both are reprinted in *Kant: Political Writings*, ed. Hans Reiss (Cambridge: Cambridge University Press, 1991), 41–53 and 61–92, respectively.

41. Nussbaum, "Kant and Cosmopolitanism," 29.

42. Martha C. Nussbaum, *For Love of Country?* (Boston: Beacon Press, 2002).

43. Martha C. Nussbaum, "Patriotism and Cosmopolitanism," in *For Love of Country?*, 7, 11.

44. Kwame Anthony Appiah, "Cosmopolitan Patriots," in Nussbaum, *For Love of Country?*, 22, 29.

45. Richard Falk, "Revisioning Cosmopolitanism," in Nussbaum, *For Love of Country?*, 53, 54, 57, 60.

46. Nathan Glazer, "Limits of Loyalty," in Nussbaum, *For Love of Country?*, 65.

47. Elaine Scarry, "The Difficulty of Imagining Other People," in Nussbaum, *For Love of Country?*, 99, 110.

48. Alan Wolfe, *The Future of Liberalism* (New York: Alfred A. Knopf, 2009), 112.

49. Ibid., 113.

50. Euben, *Journeys to the Other Shore*, 176.

51. Sami Zubaida, "Cosmopolitanism and the Middle East," in *Cosmopolitanism, Identity, and Authenticity in the Middle East*, ed. Roel Meijer (Surrey: Curzon, 1999), quoted in Euben, *Journeys to the Other Shore*, 185.

52. Carol A. Breckenridge, Sheldon Pollock, Homi K. Bhabha, and Dispesh Chakrabarty, eds., *Cosmopolitanism* (Durham: Duke University Press, 2002).

53. Ibid., 6.

54. Ibid., 8.

55. Sheldon Pollock, "Cosmopolitan and Vernacular in History," in Breckenridge et al., *Cosmopolitanism*, 15–53, quote at 29.

56. Ibid., 40.

57. Ibid., 46.

58. Mamadou Diouf, "The Senegalese Murid Trade Disaspora and the Making of a Vernacular Cosmopolitanism," trans. Steven Rendall, in Breckenridge et. al., *Cosmopolitanism*, 111, 126, 132.

59. Walter D. Mignolo, "The Many Faces of Cosmo-polis: Border Thinking and Critical Cosmopolitanism," in Breckenridge et. al., *Cosmopolitanism*, 182.

60. Seyla Benhabib, *Another Cosmopolitanism* (Oxford: Oxford University Press, 2006), 15–17, 32.

61. Ibid., 71.

62. Euben, *Journeys to the Other Shore*, 3.

63. Pollock, "Cosmopolitan and Vernacular," 47.

64. Homi K. Bhabha, *The Location of Culture* (London: Routledge, 1994), 159–60. Also see Peter Burke, *Cultural Hybridity* (London: Routledge, 2009).

65. Benhabib, *Another Cosmopolitanism*, 47.

66. Ibid., 48.

67. Alan Wolfe has argued similarly regarding value of public institutions: "Elevating the level of public discourse is the best antidote for an ignorant people." And this he claims is why public institutions are important, because they encourage reflection: "They help take us out of a state of nature, in which our opinions are likely to be emotional, and bring us into a state of society, in which our opinions are more likely to be formed." See Wolfe, *Future of Liberalism*, 196.

68. Benhabib, *Another Cosmopolitanism*, 49.

69. Bhabha, *Location of Culture*, 83–84.

CHAPTER FOUR

1. Sanjay Subrahmanyam, "Golden Age Hallucinations," *Outlook India Magazine* (August 20, 2001), http://www.outlookindia.com.

2. Jane Burbank and Frederick Cooper, *Empires in World History: Power and the Politics of Difference* (Princeton: Princeton University Press, 2010), 2.

3. Ranajit Guha, ed., *Subaltern Studies I* (New Delhi: Oxford University Press, 1982), 4. Also see Guha, ed., *Subaltern Studies Reader* (Minneapolis: University of Minnesota Press, 1997), and Partha Chatterjee, "A Brief History of Subaltern Studies," in *Empire and Nation* (New York: Columbia University Press, 2010), 289–301. Also see Robert J. C. Young, "Hybridity and Subaltern Agency," in *Postcolonialism: An Historical Introduction* (Oxford: Blackwell, 2001), 337–59.

4. Dipesh Chakrabarty, "A Small History of Subaltern Studies," in *Habitations of Modernity: Essays in the Wake of Subaltern Studies* (Chicago: University of Chicago, 2002), 14.

5. Partha Chatterjee, "Whose Imagined Community?" in *Empire and Nation*, 23–36, and Chatterjee, *The Nation and Its Fragments: Colonial and Postcolonial Histories* (Princeton: Princeton University Press, 1993), 3–13. See Benedict Anderson, *Imagined Communities: Reflections on the Origin and Spread of Nationalism* (London: Verso, 1983).

6. Partha Chatterjee, *Nationalist Thought and the Colonial World* (Minneapolis: University of Minnesota Press, 2008), first published for the United Nations University in 1986; Chatterjee, "The Constitution of Indian Nationalist Discourse," in, *Empire and Nation*, 37–58; Dipesh Chakrabarty, "Subaltern Histories and Post-Enlightenment Rationalism," in *Habitations of Modernity*, 38–50; Chakrabarty, "Reason and the Critique of Historicism," in *Provincializing Europe: Postcolonial Thought and Historical Difference* (Princeton: Princeton University Press, 2000), 237–55.

7. Chatterjee, "Constitution of Indian Nationalist Discourse," 39–47, and *Nationalist Thought*, 73.

8. Chatterjee, *Nationalist Thought*, 77–81.

9. Chatterjee, "Constitution of Indian Nationalist Discourse," 47–52, and *Nationalist Thought*, 85–130.

10. Chatterjee, *Nationalist Thought*, 86.

11. Arjun Appadurai, "Patriotism and Its Futures," *Public Culture* (Spring 1993), 413.

12. Chatterjee, "Constitution of Indian Nationalist Discourse," 52–58, and *Nationalist Thought*, 131–66.

13. Chatterjee, *Nationalist Thought*, 141.

14. Jawaharlal Nehru, *The Discovery of India* (New Delhi: Penguin, 2004), 622.

15. Chatterjee, *Nationalist Thought*, 153.

16. Guha, *Subaltern Studies I*, 5–6.

17. Rabindranath Tagore, "Nationalism in India," in *Nationalism* (London: Macmillan, 1950), 99.

18. An interesting set of essays explores the history and politics (and politicization of the historiography) of religious identities in South Asia. See David Gilmartin and Bruce B. Lawrence, eds., *Beyond Turk and Hindu: Rethinking Religious Identities in Islamicate South Asia* (Gainsville: University Press of Florida, 2000).

19. See Partha Chatterjee, "History and the Nationalization of Hinduism," in *Empire and Nation*, 59–90.

20. Sarvepalli Gopal, ed., *Anatomy of a Confrontation: Ayodha and the Rise of Communal Violence in India* (Delhi: Penguin India, 1991).

21. William Dalrymple, "India: The War over History," *New York Review of Books* (April 7, 2005).

22. Somini Sengupta, "In Religious Tinderbox, India Snuffs Spark," *New York Times* (March 16, 2002).

23. See Pankaj Mishra, "Murder in India, *New York Review of Books* (August 15, 2002).

24. Amartya Sen, "Secularism and Its Discontents," originally published in *Unraveling the Nation: Sectarian Conflict and India's Secular Identity*, ed. Kaushik Basu and Sanjay Subrahmanyam (Delhi: Penguin, 1996), republished in Amartya Sen, *The Argumentative Indian: Writings on Indian History, Culture and Identity* (New York: Farrar, Straus and Giroux, 2005), 294–316.

25. In 2009 the American Sanskrit scholar Wendy Doniger published *The Hindus: An Alternative History* (New York: Penguin Books, 2009), at the close of which she wrote, "We can learn from India's long and complex history of pluralism not just some of the pitfalls to avoid but the successes to emulate. We can follow, within the myths, the paths of individuals like King Janashruti or Yudhishthira or Chudala or, in recorded history, Ashoka or Harsha or Akbar or Mahadevyyakka or Kabir or Gandhi, or indeed most rank-in-file Hindus, who embodied a truly tolerant individual pluralism. We can take heart from movements within Hinduism that rejected both hierarchy and violence, such as the bhakti movements that included women and Dalits within their ranks and advocated a theology of love, though here too we must curb our optimism by recalling the violence embedded in many forms of bhakti, and by noting that it was in the name of bhakti to Ram that the militant Hindu nationalists tore down the Babri Mosque. We must look before we leap into history, look at the present, and imagine a better future" (689–90). She was immediately attacked by members of the Hindu right, both within Indian and abroad.

In New York, members of the Hindu Janajagruti Samit protested outside a meeting of the National Books Critics Circle where Doniger was to read from her work. (The protest was organized by the United States Hindu Alliance, which according to the group's website is dedicated to the "protection of Hindus worldwide." The group's position on Doniger's book is clear: "By giving porno-

graphic twist to Hindu objects of veneration and worship, Prof. Doniger is trying to create an illusion and authentic evidence that Hinduism is nothing but crap. This has the potential to create disaffection, disillusionment and abhorrence in the minds of Hindu children about Hindu Dharma" (http://www.hindujagruti .org/news/9004.html). Other online responses included a petition calling on the book's publisher to withdraw it from circulation and an October 31, 2009, posting on the website http://www.hinduunity.yuku.com stating, "I want to attack Wendy Doniger but I need her address and email. Can you find it for me."

26. Amartya Sen, "The Reach of Reason," in *Argumentative Indian*, 288.

27. Sen, *Argumentative Indian*, 285.

28. "This strong split between emotion and reason, I suggest, is part of the story of colonialism in India. Scientific rationalism, or the spirit of scientific inquiry, was introduced into colonial India from the very beginning as an antidote to (Indian) religion, particularly Hinduism, which was seen—by both missionaries and administrators, and in spite of the Orientalists—as a bundle of superstition and magic" (Chakrabarty, *Habitations of Modernity*, 24). And "The problem of nationalist thought becomes the particular manifestation of a much more general problem, namely, the problem of the bourgeois-rationalist conception of knowledge, established in the post-Enlightenment period of European intellectual history, as the moral and epistemic foundation of a supposedly universal framework of thought which perpetuates, in a real and not merely a metaphorical sense, a colonial domination" (Chatterjee, "Constitution of Indian Nationalist Discourse," 39).

29. Sen, *Argumentative Indian*, xiii–xiv. Sen asserts that the colonial experience not only "had the effect of undermining the intellectual self-confidence of Indians, [but] it has also been especially hard on the type of recognition that Indians may standardly have given to the country's scientific and critical traditions" (Sen, *Argumentative Indian*, 77). Chakrabarty's project is to counter the tendency among many scholars to oppose faith and reason when writing the history of India. In this he is critical of scholars on both the right and the left. Leftist intellectuals, he writes, "have sought to secure Indian secularism in the cultivation of a rational outlook. Subaltern histories that appeared to emphasize and endorse political imaginations in which gods have agency have, therefore, incurred the wrath of the Indian left." Their adoption of a "hyperrationalist" position constitutes "a failure that marks the intellect of the colonial modern. It occurs within a paradigm that sees science and religion as ultimately, and irrevocably, opposed to each other." Chakrabarty, *Habitations of Modernity*, 26–27.

30. This is the subject of Sen's recent book, *Identity and Violence: the Illusion of Destiny* (New York: W. W. Norton, 2006).

31. Ibid., 173–74.

32. Tagore, "East and West," from *Towards Universal Man*, in *The Oxford India Tagore*, ed. Uma Das Gupta (New Delhi: Oxford University Press, 2009), 279–80.

33. Quoted in Amartya Sen, "Tagore and His India," in *Argumentative Indian*, 159.

34. In 1951, ten years after Tagore's death, it became a Central University of the Government of India, securing its independent status while obtaining government funding.

35. Quoted in Martha C. Nussbaum, *Not for Profit: Why Democracy Needs the Humanities* (Princeton: Princeton University Press, 2010), 84–85.

36. Tagore, *Nationalism*, 99. It is not without interest that Tagore is the author of what would become the national anthems of India and Bangladesh (the former comprising five stanzas of a Brahmo hymn, written by Tagore and first sung in 1911; the latter comprising Tagore's 1905 song "My Golden Bengal," written during the period of Britain's early partition of Bengal).

37. *On Creative Diversity*, Report of the World Commission on Culture and Development (Paris: UNESCO, 1995), 54, http://unesdoc.unesco.org/images/0010/001016/101651e.e.pdf.

38. Homi K. Bhabha, ed., *Nation and Narration* (London: Routledge, 1990).

39. Arjun Appadurai, *Fear of Small Numbers: An Essay on the Geography of Anger* (Durham: Duke University Press, 2006), 6, 7, 10.

40. Edward W. Said, "Representing the Colonized: Anthropology's Interlocutors," in *Reflections on Exile* (Cambridge, MA: Harvard University Press, 2000), 299.

41. Edward W. Said, "The Politics of Knowledge," in *Reflections on Exile*, 376.

42. Edward W. Said, "Between Worlds," in *Reflections on Exile*," 567.

43. Edward W. Said, "The Clash of Definitions," in *Reflections on Exile*, 587.

44. Edward W. Said, "Identity, Authority, and Freedom: The Potentate and the Traveler," in *Reflections on Exile*, 385.

45. Ibid., 394, 399, 402–3, 404.

46. Edward W. Said, *Culture and Imperialism* (New York: Vintage Books, 1994), 49.

47. Ibid., 61.

48. Ibid., 61.

49. Burbank and Cooper, *Empires in World History*, 59.

50. Ibid., 288.

51. See ibid., 453–59.

52. Said, *Culture and Imperialism*, xxv.

53. Ibid., 44–45.

54. Ibid., 48.

55. Ibid., 51.

56. Finbarr B. Flood, "Between Cult and Culture: Bamiyan, Islamic Iconoclasm, and the Museum," *Art Bulletin* (December 2002), 652.

57. Alfred Gell, *Art and Agency: An Anthropological Theory* (Oxford: Clarendon Press, 1998), 97, cited in Flood, "Between Cult and Culture," 652.

58. An English translation of the edict is included as an appendix to Flood, "Between Cult and Culture," 655.

59. Barry Bearak, "Over World Protests, Taliban Are Destroying Ancient Buddhas," *New York Times* (March 4, 2001); Berak, "Afghan Says Destruction of Buddhas Is Complete," *New York Times* (March 12, 2001).

60. Barbara Crossette, "Taliban Explains Buddha Demolition," *New York Times* (March 19, 2001).

61. See http://portal.unesco.org/culture/en/ev.php-URL_ID=35362&URL_DO =DO_PRINTPAGE&URL_SECTION=201.html.

62. See http://asiasociety.org/arts-culture/how-can-afghanistans-cultural-heritage-be-preserved.html.

63. For an account of the Taliban's destruction of much of the collection of the National Museum in Kabul, see the exhibition catalog *Afghanistan: Hidden Treasures from the National Museum, Kabul* (Washington, DC: National Geographic Society, 2008).

64. Flood, "Between Cult and Culture," 653.

65. Edward W. Said, "Preface," in *Orientalism* (London: Penguin Books, 2003), xvii–xviii.

66. As in note 59.

67. See James Cuno, *Who Owns Antiquity? Museums and the Battle over Our Ancient Heritage* (Princeton: Princeton University Press, 2008).

68. Partha Chatterjee, "Our Modernity," in *Nation and Empire*, 146.

69. Appadurai, "Patriotism and Its Futures," 411.

70. Said, *Culture and Imperialism*, 311.

EPILOGUE

1. Homi Bhabha, published conversation, in *Jitish Kallat: Public Notice 3*, ed. Madhuvanti Ghose (Chicago: Art Institute of Chicago, 2011), 68–69.

2. Gyan Prakash, *Another Reason: Science and the Imagination of Modern India* (Princeton: Princeton University Press, 1999), 3–4.

3. Quoted in Kavita Singh, "Material Fantasy: The Museum in Colonial India," in *India: Art and Visual Culture, 1857–2007*, ed. Gayatri Sinha (Mumbai: Marg Publications, 2009), 49.

4. Quoted in Singh, "Material Fantasy," 45.

5. Ibid., 50–51.

6. Tapati Guha-Thakurta, "Archaeology and the Monument," in *Monuments, Objects, Histories: Institutions of Art in Colonial and Postcolonial India* (New York: Columbia University Press, 2004), 269–81.

7. *Evidence for the Ram Jamabhumi Mandir*, presented to the government of India on December 23, 1990, by the VHP, quoted in Guha-Thakurta, *Monuments, Objects, Histories*, 273.

8. *The Political Abuse of History: Babri Masjid-Ram Janmabhumi Dispute*, rev. ed. (1989; New Delhi: Centre for Historical Studies, Jawaharlal Nehru University, 1992).

9. Quoted in Guha-Thakurta, *Monuments, Objects, Histories*, 275 (emphases are Guha-Thakurta's).

10. Bhabha, published conversation, in Ghose, *Jitish Kallat*, 70.

INDEX

academic freedom, 99–100

access to information, 20–21, 23

aesthetics, 16

affaire du foulard, 25, 83–84

Afghanistan, 104, 105–9

Akbar (Mughal emperor), 94–95, 101

Alpers, Svetlana, 35, 53

Altes Museum (Berlin), 11

American Museum of Natural History, 36

Amis, Martin, 133n36

Anderson, Benedict, 90

"Answering the Question 'What is Enlightenment'" (Kant), 22–23, 133n40

Anti-Enlightenment Tradition, The (Sternhell), 26–29

Appadurai, Arjun, 97, 112

Appiah, Kwame Anthony, 62, 78

Archaeological Survey of India, 115, 116

Art Institute of Chicago: in Burnham's Plan for Chicago of 1909, 5; community identity fostered by, 6, 54–55; as encyclopedic museum, 4; framework for getting around in, 52; number of annual visitors, 1

art museums: experience as critical one, 51; gendered subjects produced by, 43; in India, 9, 118; popularity of, 2; purpose of, 53; what they offer, 2; why people come to, 1–2, 9

Art Newspaper, 2

Asiatic Society, 115, 117

Association of Art Museum Directors, 2

audio guides, 50, 52

Auerbach, Eric, 103

Babri Mosque (India), 93–94, 119–20, 136n25

Bacon, Francis, 14

Bamiyan Buddhas (Afghanistan), 104, 105–9
Bamyeh, Mohammed, 58, 77
Bann, Stephen, 45–46
Baumgarten, Alexander Gottlieb, 16
Baxandall, Michael, 41
Bellow, Saul, 133n36
Benhabib, Seyla, 83–84, 86, 87, 112
Bennett, Tony, 41–42, 44, 129n30
Berlin, Isaiah, 27
Berlin museums, 11
Bhabha, Homi, 85–86, 87, 97, 115, 120–21
Bharatiya Janata Party (BJP), 92–94
blue and white ware, 46–50, 66, 102, 130n38, Plate 1
Boas, Franz, 35–36, 37, 38, 40
Bodhisattva (Pakistan), 68, 69, 103
book clubs, 18
Brewer, John, 18
Brilliant, Richard, 129n30
Britain: imperialism in cultural foundations of India, 115–17, 121. See also London
British Museum: collection as representative of world's cultures, 13–14; cosmopolitanism of, 21; Department of Antiquities established, 15; as encyclopedic museum, 21, 121; as Enlightenment institution, 7, 21–22; establishment of, 11–13; evolution of collection, 14–15; guiding principle of, 13; independent board of trustees of, 44; instructional role of, 34; as not a national museum, 13; as open to all people, 19–20; systematic display of objects in, 33–34
British Museum Act (1753), 12, 16
Bucherer-Dietschi, Paul, 107–8, 110
Burbank, Jane, 89
Burke, Edmund, 27
Burnham, Daniel H., 5

Cahill, James, 75
Canova, Antonio, 59, 60
Chakrabarty, Dipesh, 23–24, 90, 137n28, 137n29
Chambers, Ephraim, 17, 23
Chatterjee, Partha, 90–91, 92, 111
Chattopadhyay, Bankimchandra, 91
Chicago: cultural institutions of, 5–6; diversity of, 4–5, 6; foreign-born population, 4, 6. See also Art Institute of Chicago
China: empires of, 101; returns to worldwide influence, 102. See also Chinese art
Chinese art: calligraphy, 68, 70, 73–74, 75; painting, 74–75; porcelain, 46–50, 66, 102, 130n38, Plate 1
Chinggis Khan, 101
Cicero, 112
Clement XII, Pope, 17
coffeehouses, 18
Cold Mountain paintings (Marden), 72–76, 72, 85, Plate 4
comparative literature, 8, 100, 103, 104
Condorcet, Marquis de, 86–87, 124n8
connoisseurship, 15–16
Cooper, Frederick, 89
Cortés, Hernán, 14
cosmopolitanism: of Abu Dhabi branch of the Louvre, 44; of British Museum, 21; debate over, 8; and difference, 62–63; of encyclopedic museums, 3, 6–7, 8, 57–87, 111; Enlightenment, 25–26; and globalization, 8, 77, 79, 80, 82, 83; Herder's anticosmopolitanism, 27; Humanität ideal, 28, 29; of Islamic world, 58; Latin versus Sanskrit, 81–82; neoliberal framing of, 81; "new," 80; norms of justice, 84; patriotism versus, 78–80, 83; of postcolonial civil societies, 120–21; revival of interest in, 77–84; of Visva-Bharati University, 96–97

cultural relativism, 26

culture: as always hybrid, 3, 54, 77, 85–86, 89, 97; British Museum's collections as representative of world's cultures, 13–14, 19–20, 29, 34; Chicago institutions present examples of world's cultures, 5–6; cultural dimensions of empire, 100–101; cultural nationalism, 27, 119; encyclopedic museums and hybridity of, 85, 119; encyclopedic museums present examples of world's cultures, 8, 22, 52, 55, 84, 110, 111, 121; history of as contrapuntal, 103–4; imperial cultures, 89; as national, 84; nationalized cultural property, 110; transculturation, 77

curiosity, 46

Curtius, Ernst, 103

Cyclopaedia, or an Universal Dictionary of the Arts and Sciences (Chambers), 17

Dalrymple, William, 93

Darnton, Robert, 17

David, Jacques-Louis, 13

Declaration of Independence (1776), 21

Declaration of the Rights of Man and Citizen (1789), 21

Delftware, 50

de Montebello, Philippe, 107

Derrida, Jacques, 23

dictionaries, 17

Dictionary of the English Language (Johnson), 17

Diderot, Denis, 17, 124n8

Diogenes the Cynic, 77

Diouf, Mamadou, 82

Discourses (Richardson), 15–16

Dish with Long-tailed Birds in a Garden (Yuan dynasty China), 48

Doniger, Wendy, 136n25

Duncan, Carol, 2–3, 41, 44, 45, 53, 104, 123n2

Dürer, Albrecht, 14

East India Company, 49, 102, 115, 116, 117

Elderfield, John, 38

Empson, James, 33–34, 35, 53, 54

encyclopedias, 17

encyclopedic museums: British Museum as, 21, 121; as complicating reductive formulae, 110; as cosmopolitan, 3, 6–7, 8, 57–87, 111; as disinterested, 119; Enlightenment principles in, 7, 111, 112–13, 121; and hybridity of culture, 85, 119; imperialism associated with, 8, 89–113; India lacks, 118, 121; individual agency of visitor respected by, 3–4, 7, 52–53; as iterative, 86–87; as modern institution, 11; museums strive to be encyclopedic, 53; robust data sets provided by, 29–30; as secular, 66, 104, 110, 112, 119; tolerance of difference promoted by, 54, 84, 111; translation compared with, 7, 8, 62; travel compared with, 7–8, 59, 62

Encyclopédie (Diderot), 17

Enlightenment: anti-Enlightenment tradition, 26–29; as available to everyone, 20; British Museum as institution of, 7, 21–22; colonialism associated with, 7, 23–24; connoisseurship, 15–16; cosmopolitanism of, 25–26; criticisms of, 23–24; Diderot's *Encyclopédie*, 17; encyclopedic museums employ principles of, 7, 111, 112–13, 121; the Enlightenment museum, 11–31; on freedom of

Enlightenment (*continued*)
 individual thought, 21; Kant on,
 22–23; rationalism, 24, 26; regard
 for reason seen as imported to
 India from, 95; revival of interest
 in, 24–29, 77; scientific point of
 view of, 15, 16; universalism of,
 21, 25, 26
essentialism, 3, 8, 26, 54, 84, 110, 119
Etchings to Rexroth (Marden), 71
Euben, Roxanne, 7–8, 58, 59, 63, 80,
 84–85
exploration, 14

Falk, Richard, 78–79
Fang reliquary head, 59, 61
Farago, Claire, 129n30
Flood, Finbarr, 77, 104–5, 109–10
Foucault, Michel, 3, 23, 41, 129n30
*Fountain at Villa Torlonia, Frascati,
 Italy, The* (Sargent), 66, 67
France: *affaire du foulard*, 25, 83–84.
 See also Paris
freedom: academic, 99–100; Enlight-
 enment commitment to, 22, 25; in
 liberalism, 20–21
freethinkers, 17

Gandhi, Mohandas, 91, 92
Gell, Alfred, 105
gender, 43, 44
Glazer, Nathan, 79
globalization: cosmopolitanism and,
 8, 77, 79, 80, 82, 83; market-driven
 globalism, 79; of Murid traders,
 82; nationalism increased by, 97;
 negative consequences of, 80;
 Taylor's proposed museum in con-
 text of, 39
Gopnik, Adam, 40–41, 45
governmental efforts to retain works
 of art, 76–77

Greenblatt, Stephen, 53
Grossman, Edith, 8, 62, 76
Guha-Thakurta, Tapati, 119

Hamilton, William, 15
Han Shan, 68, 70
Hashimi, Sayed Rahmatullah, 106,
 107
Hasidic community, 82
Head of Medusa (Canova), 59, 60
Herder, Johann Gottfried von, 27, 28
Hermitage (St. Petersburg), 11
Herodotus, 58, 131n7
Hindutva, 82, 92–94
Hogarth, William, 18
human rights, 20, 21, 83, 126n26
Hume, David, 20, 26, 55
Huntington, Samuel, 98
hybridity: in Bombay compared with
 Oxford, 115; culture as always
 hybrid, 3, 54, 77, 85–86, 89, 97; en-
 cyclopedic museums and cultural,
 85, 119

Ibn Battuta, 46, 57–58, 65, 131n2
iconoclasm, 104–6, 109
"Idea for a Universal History with a
 Cosmopolitan Purpose" (Kant),
 133n40
imperialism: British imperialism
 in cultural foundations of India,
 115–17, 121; cultural dimensions
 of, 100–101; empires as enduring
 and varied form of state, 101–2;
 encyclopedic museums associated
 with, 8, 89–113; Enlightenment
 associated with, 8, 23–24; imperial
 cultures, 89; nation-state has not
 eliminated empire, 102; regard for
 reason seen as instrument of, 95;
 U.S. empire, 101–2
India: Babri Mosque dispute, 93–94,

119–20, 136n25; Bombay compared with Oxford, 115; British imperialism in cultural foundations of, 115–17, 121; museums of, 9, 117–18, 121; nationalism in, 89–97

Institute of Rural Reconstruction, 96

Islamic world: *affaire du foulard*, 25, 83–84; Bamiyan Buddhas of Afghanistan, 104, 105–9; cosmopolitanism of, 58; Ibn Battuta's travels in, 57–58, 65, 131n2; Murid traders, 82; Muslims in India, 92–94, 119; talismanic textile, 65–66, Plate 2; trade in Chinese porcelain, 46–47, 130n37

"life groups," 36

Linnaeus, Carolus, 12

Lives of the English Poets (Johnson), 18

Locke, John, 16, 26

London: book clubs and libraries in, 18; coffeehouses in, 18; growth of, 18–19; as international entrepôt, 19; newspapers and periodicals in eighteenth-century, 17–18. *See also* British Museum

Louvre (Paris): Abu Dhabi branch of, 44; evolution of, 11; as national museum, 13, 44; state power attributed to, 44–45

Lyotard, Jean-François, 23

Jefferson, Thomas, 21

Johnson, Samuel, 17, 18

Judt, Tony, 57

Kabul Museum, 108, 109, 110

Kalm, Per, 12

Kant, Immanuel: on critique, 7, 54, 87; on enlightenment, 22–23; on freedom, 20–21, 25; "Idea for a Universal History with a Cosmopolitan Purpose," 133n40; *Perpetual Peace*, 77, 133n40; revolt against Enlightenment of, 26; universal values of, 25, 81

Kapuścínski, Ryszard, 58, 131n7

kendi, 48

Khubilai Khan, 101

Kipling, Rudyard, 117

kundika, 48–49

labels, 50, 52

Lafayette, Marquis de, 21

Latin, 81–82

liberalism, 20–21, 52, 54

libraries, 18

Macdonald, Sharon, 128n21

MacGregor, Neil, 14, 119

Marcus Aurelius, 62

Marden, Brice: *Cold Mountain* paintings, 72–76, 72, 85, Plate 4; *Etchings to Rexroth*, 71; *Zen Studies*, 68–71, 70, 71, 73

metanarratives, 7, 23, 44

Mexican vase, 49

Mignolo, Walter, 83

mongrelization, 54, 62, 68, 85

Montebello, Philippe de, 107

Monthly Review, 23

Murdoch, Iris, 51

Murid traders, 82

Museum of Modern Art (MoMA) (New York), 38–41

museums: academic critique of, 2–3, 7, 41–43, 51–52, 53–54; arrangement of objects in, 33–55; in Burnham's Plan for Chicago of 1909, 5; characterized as metanarratives, 7, 23; collections make no pretense completeness, 53; core mission to collect, preserve, and display, 34; the cosmopolitan museum, 57–87; as discursive sites, 33–55; as disin-

museums (*continued*)
terested, 119; the Enlightenment
museum, 11–31; experience as
critical one, 51; gendered subjects
produced by, 43, 44; and hybridity
of culture, 85, 119; the imperial
museum, 89–113; of India, 117–18,
121; individual agency of visitor
respected by, 3–4, 7, 52–53, 104; as
liberal institutions, 52; objectivity
sought by, 51; objects tell stories,
34–35, 68, 76; power attributed to,
2–3, 7, 41–45, 51–52, 53–54, 129n30;
professionalism of, 37; script or
narrative account of experience
of, 59; as secular, 66, 104, 110, 112,
119. *See also* art museums; ency-
clopedic museums

Nabokov, Vladimir, 33, 50
Naipul, V. S., 58, 131n7
National Gallery (London), 35
nationalism: cultural, 27, 119; cul-
tures as national, 84; empire not
eliminated by nation-state, 102;
fundamentalist, 8, 82; globaliza-
tion increases, 97; Hindutva, 82,
92–94; Indian, 89–97; national-
ized cultural property, 110; as only
first step, 99; patriotism versus
cosmopolitanism, 78–80, 83;
political, 27–28; reductive, 9, 26,
100; thinking ourselves beyond
the nation, 112; universities in
shaping national identity, 98–99
"Nationalism in India" (Tagore), 92, 96
National Museum of India, 115–17
Natural History Museum (London), 15
natural philosophy, 16
Nehru, Jawaharlal, 91–92
newspapers, 17, 23
Ni Zan, 74, 75
Nussbaum, Martha, 77–79

objectivity, 51
Oljeitu, Il-Khan, 101
Omar, Mullah Muhammad, 106, 107

Paris: London surpasses in popu-
lation, 18, 19; riots of 2005, 24–25.
See also Louvre (Paris)
Parthenon Marbles, 15
particularism, 27, 28, 80
patriotism, versus cosmopolitanism,
78–80, 83
"Patriotism and Cosmopolitanism"
(Nussbaum), 78
Pergamon Museum (Berlin), 11
periodicals, 17–18, 23
Perpetual Peace (Kant), 77, 133n40
Plan for Chicago (1909), 5
Plaque of a War Chief (Benin), 63–65,
64, 102–3
pluralism, 26, 81, 82, 83, 94, 101, 113
Pollock, Jackson, 75
Pollock, Sheldon, 81–82, 85
Polo, Marco, 46
porcelain, Chinese, 46–50, 66, 102,
130n38, Plate 1
postal service, 23
postcolonial theory, 23–24, 85, 90,
98, 112
postmodern theory, 54, 128n21
Prakash, Gyan, 116
Prévost, Abbé, 18
Preziosi, Donald, 42–43, 52, 129n30
public sphere, 18, 20, 55

Qur'án, 24, 65

rationalism, 24, 26, 137n28, 137n29
reason: Akbar on, 94, 95; anti-
Enlightenment view of, 27, 28;
Chatterjee on politics and, 92; in
connoisseurship, 16; in Diderot's

Encyclopédie, 17; encyclopedic
museums and exercise of, 31, 55,
104, 110, 112; Enlightenment view
of, 11, 22, 26, 29; Kant on, 22, 26,
78, 81; public use of, 54, 55, 112;
versus religion, 95, 137n29; seen
as instrument of imperial power,
23–24, 95, 137n28; Sen on, 95;
Tagore on, 96
Re:Enlightenment Project, 24
relativism, 26
Rexroth, Kenneth, 71
Richardson, Jonathan, 15–16, 18
Ricoeur, Paul, 58–59
Roland, Jean-Marie, 13
Roman Empire, 101
Rorty, Richard, 62
Roubiliac, Louis-François, 18

Said, Edward, 8–9, 98–101, 103–4,
110, 112
Sanskrit, 81–82
Sargent, John Singer, 66, 67
Sarkozy, Nicolas, 44
Sayaji Rao of Baroda, 118
Scarry, Elaine, 79
Sen, Amartya, 94–95, 96, 137n29
Seneca, 77
Serra, Richard, 40
Singh, Kavita, 117–18
Sinha, B. P., 119–20
Sloane, Sir Hans, 12, 18, 19–20, 55,
125n19
Sternhell, Zeev, 11, 26–29
Stoics, 77, 78
Subaltern Studies Collective, 90, 92
Subrahmanyam, Sanjay, 89
Sufism, 65

Tagore, Rabindranath, 92, 95–97,
138n35
Taine, Hippolyte-Adolphe, 27

Taliban, 106–9, 110
talismanic textile (Senegal), 65–66,
Plate 2
Tata family, 118
Taylor, Mark, 39
*Thangka with Bhaishajyaguru, the
Medicine Buddha* (Tibet), 66, Plate 3
Thapar, Romila, 120
Tibetan Buddhism, 66, Plate 3
Todorov, Tzvetan, 24–26, 28–29
Topkapi Saray (Istanbul), 47
transculturation, 77
translation: encyclopedic museums
as akin to, 7, 8, 62; enriches the
nature of language, 76; Marden
paintings as, 75–76; travel as term
of, 62; in works of art, 54
transnational corporations, 79
travel: changes our sense of the
world, 58–59; encyclopedic muse-
ums compared with, 7–8, 59, 62;
of Ibn Battuta, 57–58, 65, 131n2;
involuntary, 63–66; as transla-
tion, 62
Trilling, Lionel, 51, 54
Tschumi, Bernard, 39–40
"two art histories" divide, 129n30

United States Hindu Alliance,
136n25
universality, 21, 25, 27, 81, 82, 83, 111
universities, 98–99

Valéry, Paul, 37–38
Varnedoe, Kirk, 39
vernacularity, 82
Vico, Giambattista, 26–27
Vietnamese ceramics, 47
Vishva Hindu Parishad (VHP), 94,
119, 120
Visva-Bharati University, 96–97,
138n34

Wallach, Alan, 2–3, 41, 45, 104, 123n2
Wolfe, Alan, 52, 79–80, 134n67

Xuanzang, 58, 131n7

Zen Studies (Marden), 68–71, 70, 71, 73
Zhao Mengu, 75
Zubaida, Sami, 80